JASMINE

1^{re} de couverture :
Léonardo da Vinci, 1452-1519. Madonna with a Flower (The Benois Madonna),
Oil on canvas, transferred from panel,
49,5 × 31,5 cm;
Received from the collection of M. Benois in Petrograd, 1914 (Inv. No. 2773).

4^e de couverture :
Jasmin-picking. Grasse Region, Eldée, c. 1950.
Archives of the Musée d'Art et d'Histoire de Provence

Publishing Director : Paul ANDRÉ
Designer : GRAPHIDIAS

Printed by SAGER (La Loupe)
for Parkstone Publishers
Copyright 2nd term 1996
ISBN 1 85995 170 8

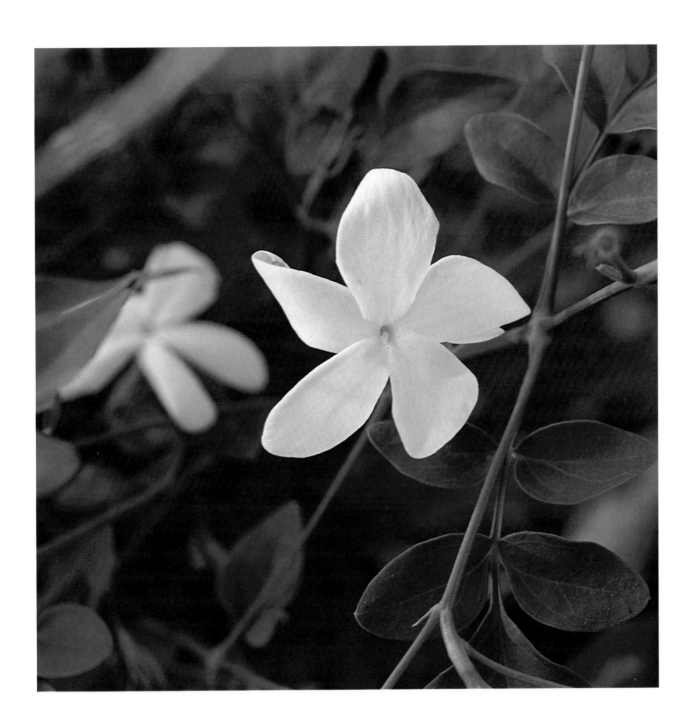

Jasmine, the Flower of Grasse
Jasminum grandiflorum Linnaeus

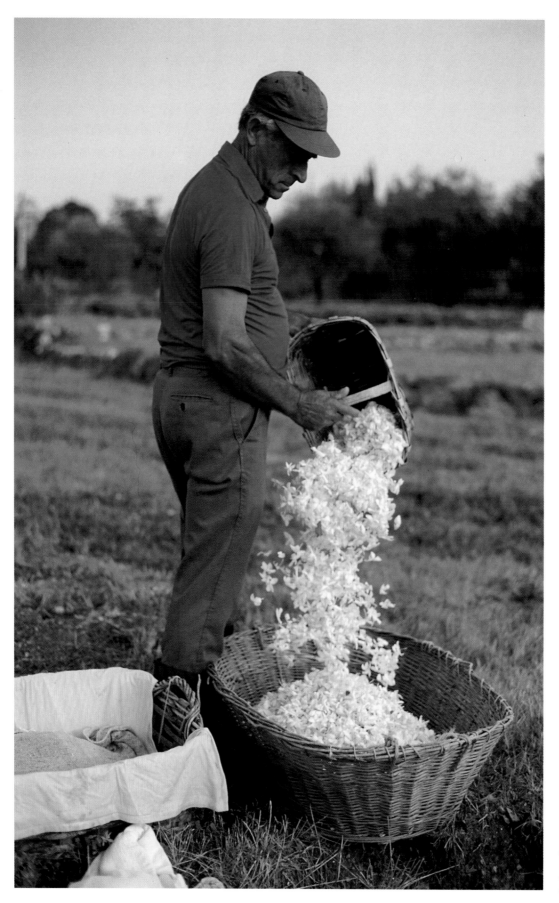

*Jasmine-picker emptying
his basket
Plascassier, summer, 1995
M.I.P. Archives*

JASMINE

Flower of Grasse

Jasmine, the Flower of Grasse
Jasminum grandiflorum
Linnaeus

FOREWORD

"Jasmine, Flower of Grasse"

Grasse, the cradle of the French perfume industry, is pleased to pay particular homage today to one of the most prestigious flowers, the jasmine.

This flower is such a vast subject area that the exhibition we are devoting to it has required the cooperation of both of the town's museums, Le Musée International de la Parfumerie et le Musée d'Art et d'Histoire de Provence (the International Perfumery Museum and the Provence Museum of Art and History).

The history of jasmine is a long and rich one. Imported from India to Grasse in the 17th century, it began to be grown for its main fragrances throughout the Mediterranean basin (Spain, Italy, Egypt...) from the 18th century. Its importance in this region of ours is such that it is known simply as "The Flower".

At the same time, whilst the botanists of the 17th century were studying it and reproducing it in botanical collections, artists very quickly appropriated it. It brightens the paintings of Dutch painters such as Bruegel le Velours, and it is also a symbol of purity. However, it was too delicate and too small to appear in bouquets of flowers, and so was abandoned by the Art Nouveau movement and sank into oblivion.

"Jasmine, Flower of Grasse" will provide the opportunity for the Musées de la Ville de Grasse (Grasse Municipal Museums) to unveil to the public the exceptional diversity of use of this flower through art, perfume and fashion. This exhibition is therefore aimed at everyone and is an invitation to embark upon a fragrant journey.

I should like to take this opportunity to thank all those who have contributed to this exhibition: patrons, industrialists, national and regional organisations and organisations of the Départements, in particular the local government departments and the Museum staff, who have spared no effort in making this event a success.

Jean-Pierre LELEUX
Mayor of Grasse

Jasmine-scented pommade
Paper label.
5 cm × 8.5 cm
Early 20th century
M.I.P. Collection

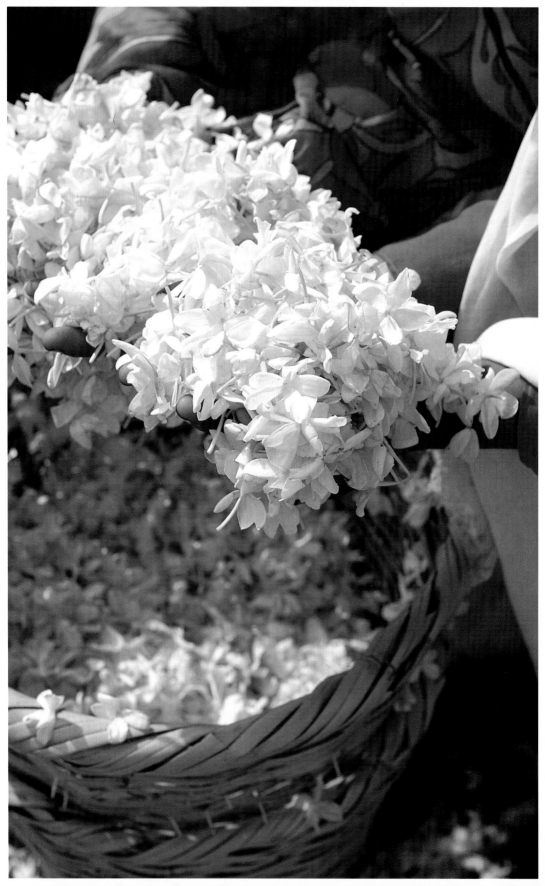

PREFACE

I n the context of the 47th Jasmine Festival, a great popular summer event, the Musées de la Ville de Grasse (the Grasse Municipal Museums) were naturally appointed, due to the nature of their collections, to organise a large exhibition devoted to one of the most important flowers used in the perfume industry, jasmine.

This fragrant, colourful journey through several centuries and various countries will lead us to discover a flower as exceptional as it is unfamiliar to the general public, the artistic representation of which has scarcely been studied, except by a few specialists. The imagination of the drawings and the most varied representations in the decorative arts or again in furniture, will be a real revelation. They will give jasmine the position it unfortunately lost with the advent of Art Nouveau, because the fragility and small size of the flower did not lend themselves to the convolutions imposed by this new trend.

The journey would not be complete if the position in the Grasse flower growing industry of *Jasmine grandiflorum L.*, better known as Spanish Jasmine, was omitted. Introduced to the region in the 17th century, it only started to be grown in open fields from Vence (Alpes-Maritimes) to Seillans (Var) in the 19th century. Since that time, the level of production and amount of land under cultivation have, in practice, continued to decline. It was therefore time to pay homage to the White Flower, the subtlest fragrances of which are extracted in Grasse by the industrialists, to the great delight of the perfumers, who reserve it for their most prestigious creations.

Marie-Christine GRASSE
Curator of the Musées de Grasse

Facing page: Armful of jasmine
Egypt, summer, 1995
M.I.P. Archives

Left: "Jasmine"
The Guérlain perfume
Paper label
2.6 cm diameter
Early 20th century
M.I.P. Collection

Jasmine from which a sweet breath rises,
Flowers which no winds have dulled,
Aminta clothed in white is your equal,
And you remind me of her.

Jean de la FONTAINE :
L'orangerie, 17th century.

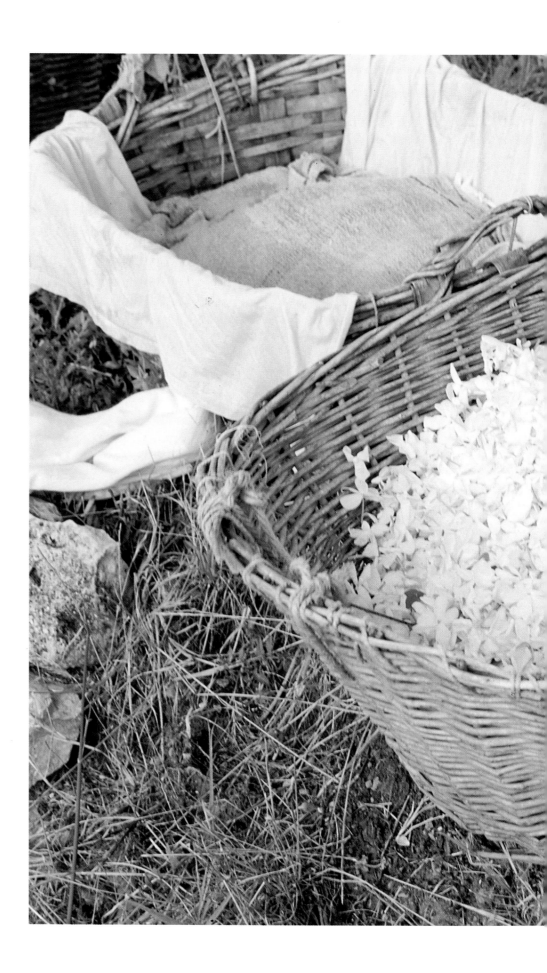

Basket of jasmine
Plascassier, summer, 1995
M.I.P. Archives

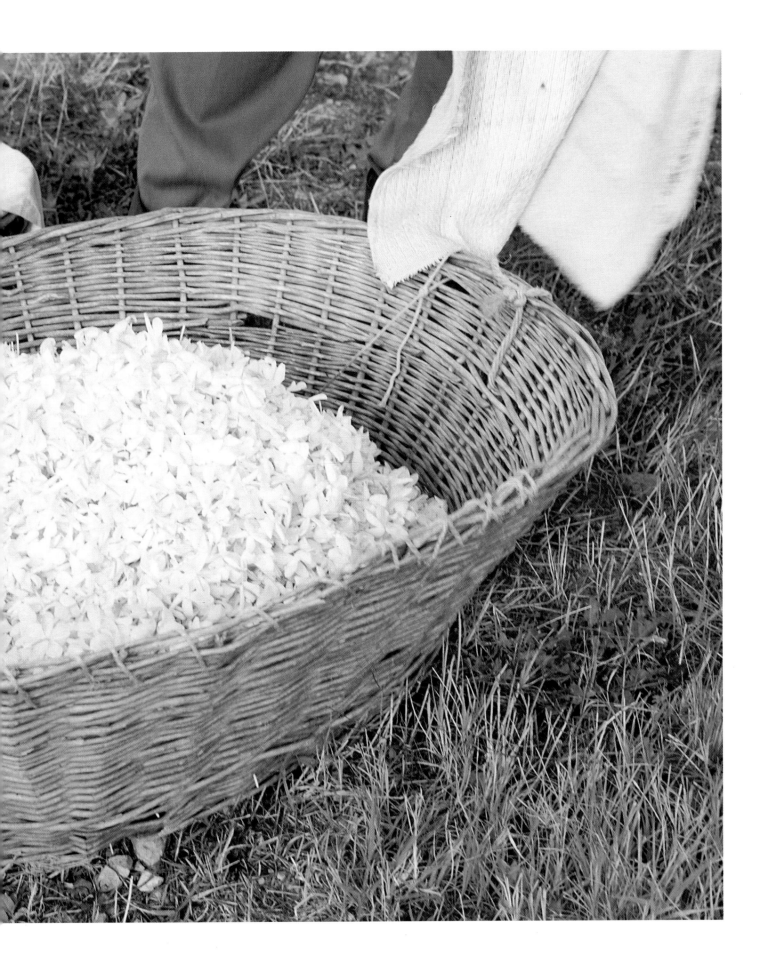

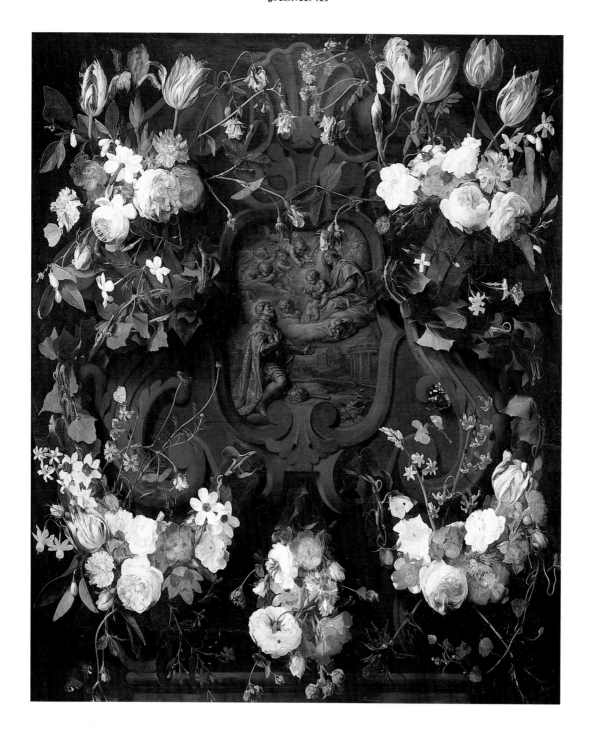

Garlands of flowers surrounding a medallion
Gérard Seghers, 18th century
Oil on canvas
Musée Fabre, Montpellier
© F. Jaulmes

JASMINE IN WESTERN ART

Adam and Eve have already been expelled from the Garden of Eden, a miraculous place where the plant life is balanced, and flowers abound... The craftsmen of the Valley of the Nile already delight in painting the papyrus and lotus on the walls of the tombs,... the ultimate statements of their love of the good life.

The Cretan ceramists are already painting crocuses or other flowers on vases.

According to Pliny, pictures of flowers have been painted since the time of Alexander.

In the Middle Ages, the Dominican, Albert le Grand, devoted a chapter to *De plantatione viridarium*, in his "Treatise on Plants".

Tapestries with the thousand flowers of the hanging of the unicorn show lilies, roses, carnations, irises... Herbs and flowers decorate princely dwellings, while flowers are used in ceremonies and religious processions. There is no trace here, however, of any jasmine.

In a representational work, the artist searches for a compromise between the imitation and expression of his thought. Symbolism begins to develop each time the artist exhausts his source of inspiration in nature. Thus painters, fascinated by the beauty of flowers which stir their imagination, express the inexpressible through allegory and symbol. But must the artist conform to the aesthetic constraints of nature... ?

Flowers braided into wreaths also take on several meanings. Thus the first Christians symbolised paradise with wreaths of flowers painted close to the figures. Jasmine was frequently portrayed in the Renaissance accompanied by roses and lilies arranged as a wreath around the Virgin, saints or angels, as in *La Vierge à l'enfant avec Saint-Jean* (the Virgin and Child with St. John) by Filippino Lippi, kept at the National Gallery in London. Jasmine, with its white star shape and sweet scent, is one of the symbols of the Virgin, probably confused with myrrh, a different symbol for Mary. Yellow jasmine thus appears in the wreath of symbolic flowers of the 17th century *La Vierge à l'enfant* (Virgin with Child), attributed to Frans Ykens and Gérard Seghers. What is more, this crown of attributes here supplants the main figures.

Flowers in the works of Van Eyck or the German masters form an entity with Christ and the Saints, and the artists take an entirely new pleasure in reproducing them. Jasmine symbolises grace, elegance, and kindness, – meanings which are directly derived from the morphology of this graceful, elegant, delicately perfumed plant. Botanical naturalism emerges in Van Eyck's *L'Agneau Mystique (Adoration of the Mystic Lamb)*. It was developed by the illuminators of northern Europe at the end of the 15th century when they were weary of painting religious scenes.

The talents as botanists of all these painters have been exercised over the known flora of Europe since antiquity, at a time when rare plants and flowers could be seen flooding in from different parts of the globe. Botanical gardens, such as those

in Padua in 1543, were created to collect them. Botany developed rapidly in the second half of the 16th century. In 1601, the Flemish Charles de l'Escluse devoted a work to rare plants, *Rariorum plantarum*, which is a huge illustrated natural history collection.

*　*
*

From the 16th century, the bouquet of flowers became the pretext for painters to show off their brilliance. It was a favourite subject when the art of illumination was on the decline. Floral print-making, however, was caught up in an ever-changing organic movement, making it difficult to establish stages of style marked by innovations in the treatment attributed to this or that artist. Exotic flowers were the subject of greatest interest, coming from the East or West Indies. In 1521, the Spanish discovered superb gardens in Mexico. But it was Turkey, in the second half of the 16th century, which would be the greatest source of enrichment for our gardens. The extreme refinement of the Persian courts had prompted them to grow flowers which their priests celebrated. Vienna was the gateway to Europe for oriental flowers, Madrid the gateway for South America. From then on, these flowers slowly spread into the countries of the Holy Roman Empire, into Germany

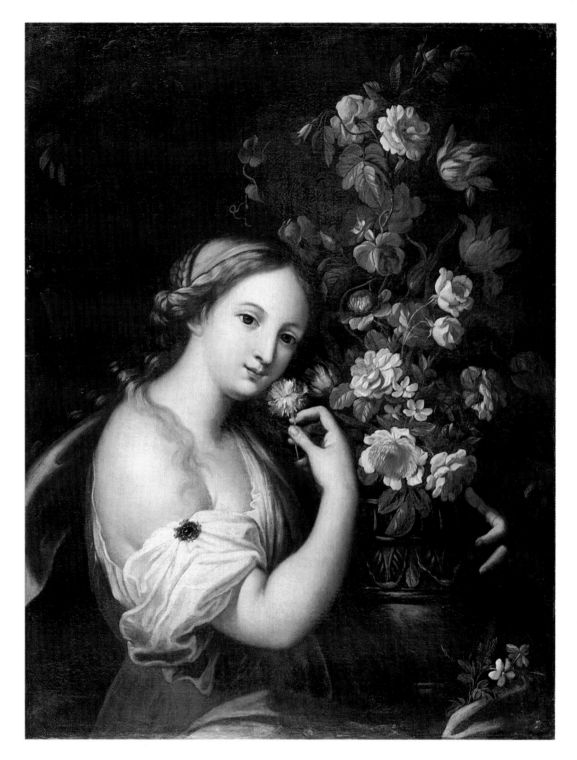

▲ *Above:*
Allegory of the Sense of Smell
Young girl clasping a bouquet of flowers
Oil on canvas
© Musée des Beaux-Arts, Nantes

◄ *Facing page: A Garland of Flowers*
Gaspar Pieter Verbruggen II
© Musée des Beaux-Arts, Quimper
© Driver's

and the Netherlands. They were the favourite source of inspiration of the Mannerist painters.

It is natural to think that this taste for flowers would create a new pictorial genre. Flanders seems to have preceded other countries in this respect. The oldest dated paintings of flowers are those of Jan Brueghel (1568 – 1625), who portrayed jasmine flowers in his work.

From Brueghel's correspondence with Cardinal Borromeo, we know that these painters worked in botanical gardens themselves in order to produce bouquets, and even real herbaria. Catalogues of floral shapes were thus formed and used in various pictures. *Gabrielle d'Estrées au bain* (Gabrielle d'Estrées bathing), attributed to the French School of the beginning of the 17th century and kept in the Musée Condée, displays genuine botanical studies in its compositions of plants. At the same time it makes a distinction between white jasmine and yellow jasmine, *Jasminum fructicans L.*.

<p style="text-align:center">* *
*</p>

This approach continued throughout the whole first half of the 17th century, as *Guirlande de fleurs* (Garland of Flowers) by Gaspar Pieter II Verbruggen shows, or the *Grand bouquet de fleurs* (Large Bouquet of Flowers) by Jan van Huysum.

The inlaid coloured mosaics of the Florentine specialists then included botanical reproductions, where the jasmine flowers appeared in their tables or pictures of hard stone. These works certainly inspired the cabinet makers who transposed the same motifs on to wood. This form of decoration may undoubtedly be called

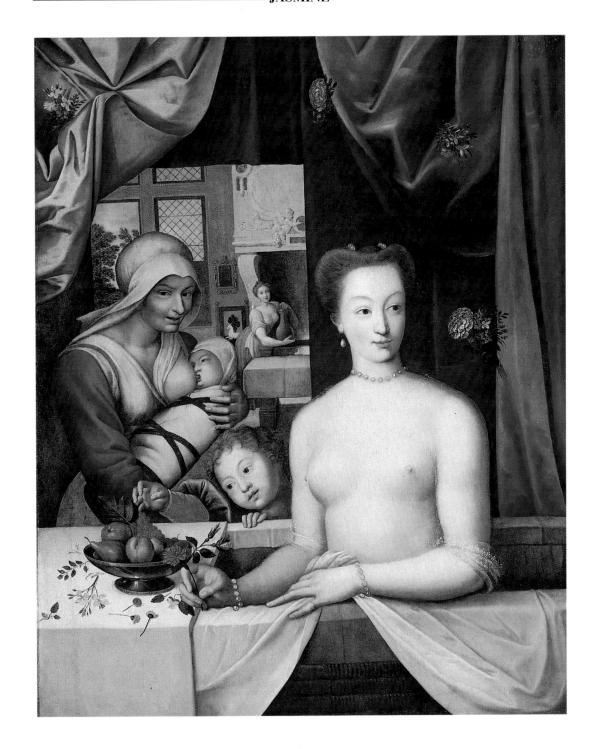

▲ *Above:*
Gabrielle d'Estrées in her Bath
French school, early 17th century
Photo: Giraudon
© *Musée Condé, Chantilly*

◄ *Facing page:*
Still Life of Flowers, Fruit and Vegetables
Anonymous
Rome, late 17th century
© *B. Voisin, Musée des Beaux-Arts, Nantes*

"floral" marquetry, since furniture thus adorned is designated by this term, as if it were a material. Gole's inventory mentions *"a floral table"*, *"a floral writing desk"*. In the second half of the 17th century, naturalist floral marquetry was practised throughout a large part of Europe: from at least 1657 in Paris; by Leonardo van der Vinne working in Florence from 1659, in the Netherlands and in England. Marquetry with floral designs was very successful from the 17th century with Jan Van Meheren, until around 1900 with Majorelle.

The taste for luxury of the Court of Versailles was rediscovered in all its artistic expressions. Textiles in particular would become the most flowery of all the decorative arts. It must be said that the brilliance of the Lyon silk artists meant that nature could be faithfully reproduced.

In every instance the artist's precision is so great that the flowers can be identified. They were arranged so as to be seen from their most characteristic angle.

In the reign of Louis XIV, the flower became the dominant element of the still lives of Jean-Baptiste Monnoyer (1634 – 1699), Jean-Baptiste Blin de Fontenay (1653 – 1715),... adorning mantelpieces, carpets and textiles in the apartments,... whilst the portraits of the women are embellished with garlands of flowers.... Floral painting also occupied painters specialising in the Manufacture des Gobelins (the State factory of Gobelin tapestry in Paris).

In 1715, Boulle's stocks consisted of *"one hundred and seventy sketches and studies of flowers painted to life"* and *"approximately fifty sketches of birds painted to life by Patel son"* which he must have used as a model for marquetry.

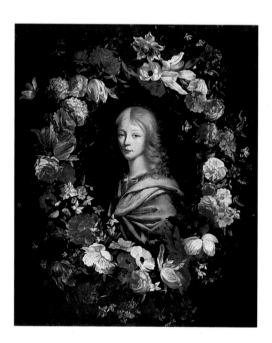

Jesus as a youth
encircled by a wreath including jasmine
Jean-Baptiste Monnoyer
(Lille, 1634 - London, 1699)
Oil on canvas
Photo P. Jean, Musée des Beaux-Arts, Nantes

Above:
Drop-leaf secretaire
Second third of the 19th century
Marquetry and inlay
Work of a Nice furniture-maker
Gift of the de Jonquières family
Collection of the Musée d'Art et
d'Histoire de Provence, Grasse

This highly multi-coloured floral marquetry used tropical and indigenous wood. The essential oils listed in Gole's stock are very revealing about the effects sought: Brazilian rosewood, purple wood, yellow wood, purplish-red wood, green ebony, orange wood, cedar, etc.. Certain pieces of furniture on Gole's list are stated as *"marquetry in four colours"* (or *"in three colours"*). Two writing tables and a bookcase *"in four colours"* were also found subsequently at Etienne Fromager's in 1702.

Eventually, some flowers such as jasmine were executed in ivory and certain details, as in coloured wood parquet, were executed in pewter, such as the pillars of the central leaf of the large closet in the *Victoria and Albert Museum*. The wood used for the base is usually ebony. Instead of being formed from a plank of wood, however, the base could be in ivory or shell, as Daniel Alcouffe indicated at the beginning of the reign of Louis XIV.

* *

*

The 18th century is generally regarded as the century of botany.

In the 18th century, girls from good families had a teacher of floral print-making. Pierre-Joseph Redouté remains one of the best known (1759 – 1840).

Gérard van Spaendonck (1746 – 1822) and Jan Franz van Dael (1764 – 1840) are unanimously recognised as painters of flowers – rose, jasmine.... G. van Spaendonck launched a collection entitled, *"Flowers drawn to life with a collection useful for amateurs, young artists, pupils of the central schools and draughtsmen working in factories"*. This genre of work undoubtedly influenced the decorative arts in general and earthenware in particular. Each park had its own botanical garden and allegorical monuments where people would delight, as Jean-Jacques Rousseau did, in finding the image of an idealised world.

Right: Detail of marquetry

* *
*

Romantic painting of the 19th century put a damper on the artists' interest in flowers and, therefore, in jasmine. We had to wait for the Impressionists at the end of the century, who once again found an invaluable attribute in the flower for their processes. Those blobs of colour and chromatic variations in their tones according to the seasons supplants the species. Monet thus observed water lilies, Renoir roses and Van Gogh sunflowers.... But jasmine had once again sunk into oblivion.

* *
*

At the beginning of the 20th century, flowers played a major role in Art Nouveau. The plant kingdom invaded furniture, decorative objects and even architecture. But the jasmine flower, too small and fragile, was no longer part of the repertoire of prints.

Present artistic trends, centred on the informal, show no interest in jasmine flowers, or in any other for that matter.

Marie-Christine GRASSE,
Curator of the Musées de Grasse

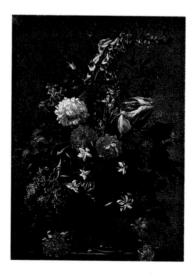

Bouquet of Flowers
Antonio Mezzadri
Oil on canvas, 17th century
© Musée des Beaux-Arts, Caen
Photo by Martine Seyve

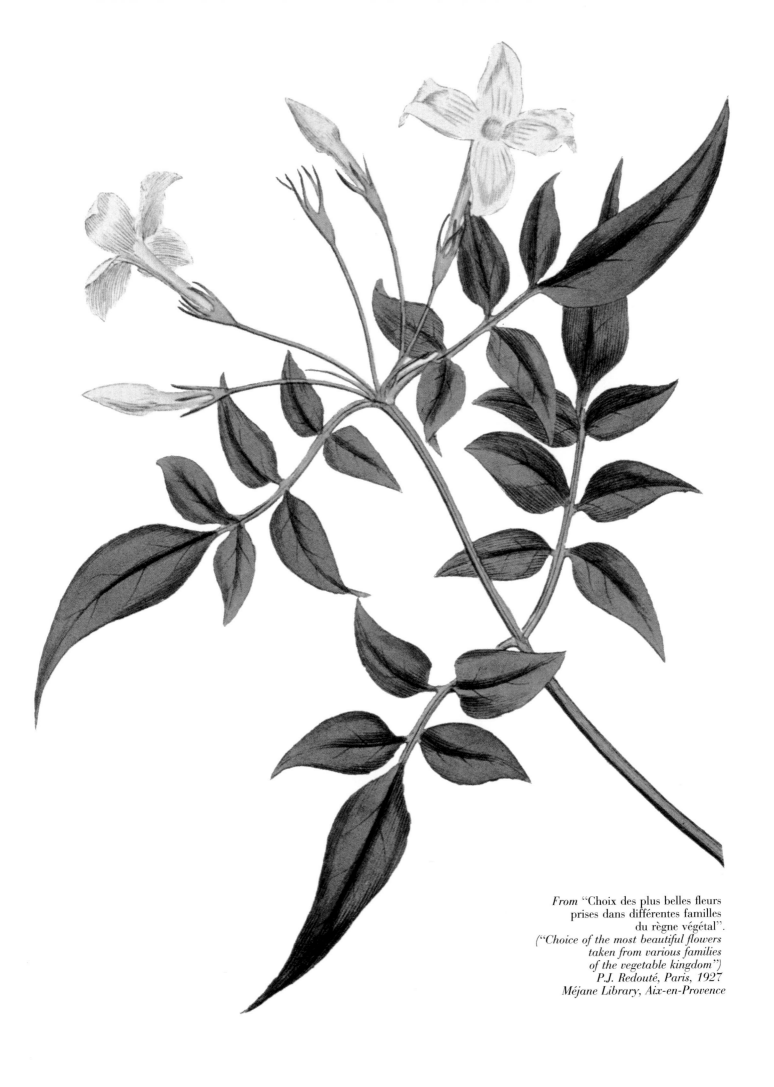

From "Choix des plus belles fleurs
prises dans différentes familles
du règne végétal".
*("Choice of the most beautiful flowers
taken from various families
of the vegetable kingdom")
P.J. Redouté, Paris, 1927
Méjane Library, Aix-en-Provence*

Louis XIV console table (detail)
17th century
Marquetry in various woods,
including pernambuco,
tulip, holly and boxwood
inlaid on ebony
Limewood carved
and gilded pedestal
Jean Gismondi Gallery, Paris

BIBLIOGRAPHY

ALCOUFFE Daniel, « Le règne de Louis XIV », *in Antiquités et objets d'art: le mobilier français de la Renaissance au style Louis XV*, Paris, éditions Fabri, 1991.

BAZIN Germain, *Les fleurs vues par les peintres*, Lauzanne, 1984.

BECKE J.B. von der, *Bouquets de fleurs. Prints from the Seventeenth and Eighteenth centuries offred for sale by J.B. von der Becke.*

BRUNET M., PREAUD T., *Sèvres des origines à nos jours*, Fribourg, Office du Livre, 1978.

COATS A., *A Book of Flowers*, London, Phaidon, 1973-1974.

COATS A., *The Treasurys of Flowers*, London, 1975.

VARIOUS, *Flowers and plants: drawings, prints*, Exhibition catalogue, Rijksmuseum, Amsterdam, 1994.

VARIOUS, *Symbolique et botanique: le sens caché des fleurs dans la peinture au XVIII^e siècle*, Exhibition catalogue, Musée des Beaux Arts, Caen, 9 July – 29 October 1987.

VARIOUS, *Flowers into cut: floral motifs in European paintings and decorative arts*, Kunstendustrimuseet, Copenhagen, 1990.

VARIOUS, *Fiori e giardini Estensi a Ferrara, la flora rinascimentale di Luca Palermo*, Palazzina Marfisa d'Este, Ferrara, 26 September – 8 November, 1992.

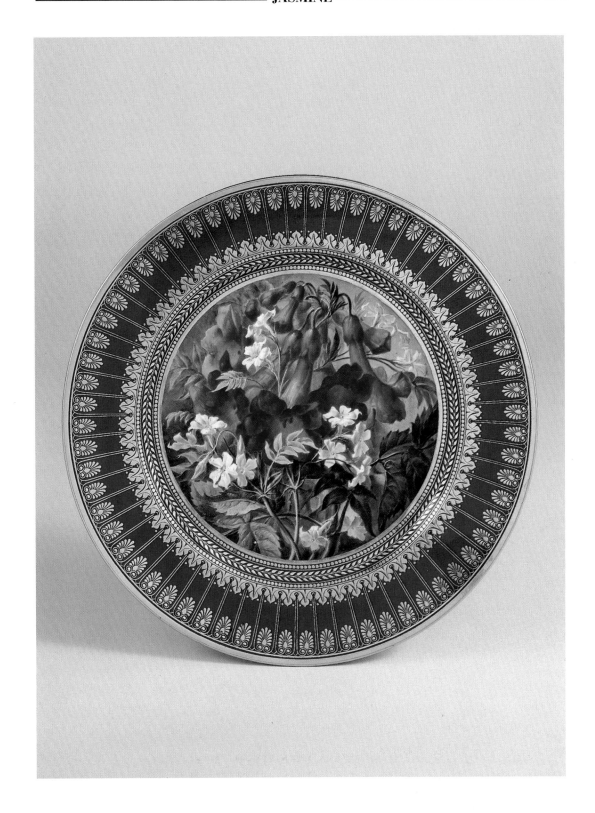

▲ *Sèvres dish painted with*
Virginian trumpet creeper
(Campsis sp.)
and common jasmine
(Jasminum officinalis)
Porcelain, 1837
Musée National de Céramiques, Sèvres

VARIOUS, *Il giardino di flora: natura e simbolo nell' immagine dei fiori*, Loggia della Mercangia, Genoa Exhibition, 25 April – 31 May 1986.

VARIOUS, *Les fleurs dans le jardin au XVII^e siècle*, paintings, vellum, prints and works of the museum and library services of Paris and Versailles, Ecole Nationale Supérieure d'Horticulture, Versailles, 15 June – 23 June 1974.

VARIOUS, *Human shape and flower*, K Matsushita Foundation Museum, Osaka, 1990.

VARIOUS, *Flore en Italie. Parcours floral, symbolique et représentation de la flore dans la peinture italienne du Moyen Age à la Renaissance*, Exhibition catalogue, Avignon, 1991.

VARIOUS, *Musées en fleurs, plantes et archéologie. La fleur dans l'art populaire alsacien. Fleurs et papier peint. La fleur au XIX^e et au XX^e siècles dans les collections du Musée des Beaux Arts*, Strasbourg, 1988.

VARIOUS, *Peintres de Fleurs en France du XVII^e au XIX^e siècle*, Petit Palais, Paris, 1979.

DUNTHORNE Gordon, *Flower and fruits prints of the 18th and early 19th centuries, their history, makers and uses*, London, 1938.

FRAIN Irène, *La Guirlande de Julie, Dictionnaire du langage des fleurs afin de déchiffrer nos tendres messages floraux*, éditions Robert Laffont, Paris, 1991.

GORDON R., FORGE A., *Les dernières Fleurs de Manet*, Herscher, Paris, 1986-1987.

GRAFE Etienne et HARDOUIN-FUGIER Elisabeth, *Les peintres de fleurs en France de Redouté à Redon*, Paris, 1993.

GRUBER Alain, *Blumen Motiven vom späten Mittelalter bis zum 19. Jahrhundert. Blumen Textilen mit naturalistischen?* (word missing here), 24 May – 24 Oct. 1986.

HARDOUIN-FUGIER E., GRAFE E., *The Lyon School of Flower Painting*, Leigh-on-Sea, Lewis, 1978.

HARDOUIN-FUGIER E., GRAFE E., *Peintures de FLeurs de l'Ecole lyonnaise*, Lyon, Musée des Beaux-Arts, 1979.

HARDOUIN-FUGIER E., GRAFE E., *Fleurs de Lyon*, Lyon, Musée des Beaux-Arts, 1982.

HARDOUIN-FUGIER E., GRAFE E., *French Flower Painters*, London, Wilson, 1989.

HARDOUIN-FUGIER E., GRAFE E., *La Gloire deLyon*, Gifu, Japon, 1990.

HARDOUIN-FUGIER E., GRAFE E., *Les peintres de la fleur en France*, Paris, 1992.

LEVI D'ANCONA Murella, *The garden of the Renaissance Botanical Symbolism in Italian painting*, Florence, 1977.

PINAULT Madeleine, *La peinture et l'histoire naturelle*, éditions Flammarion, Paris, 1990.

VILLARD T., *Les fleurs à travers les âges et à la fin du XIX^e siècle*, Paris, Magner, 1900.

▶ *Facing page:*
Orange jasmine scent label paper
8.1 cm × 7 cm
First half of 20th century
M.I.P. Collection

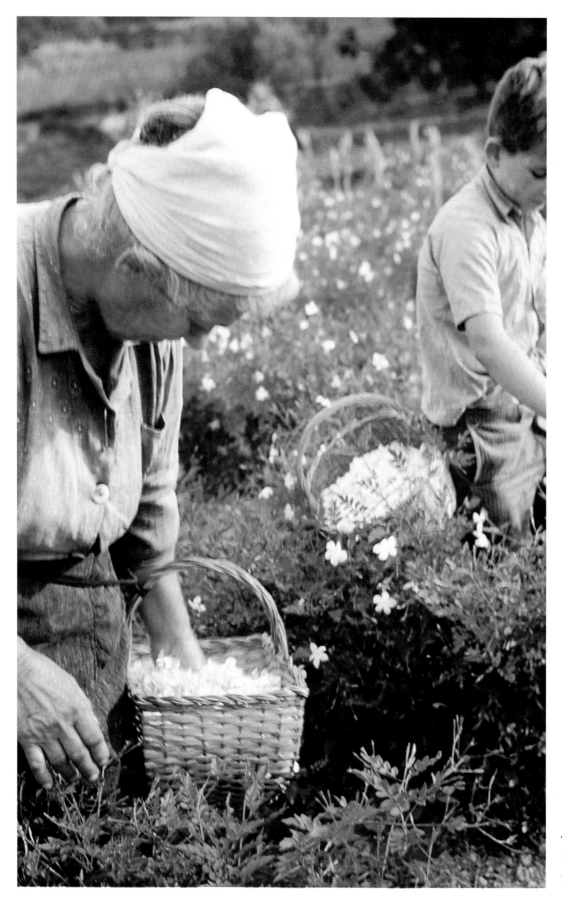

Jasmine-picking
Eldée, Grasse region
c. 1950
Archives of the Musée d'Art
et d'Histoire, Provence

JASMINE, THE STAR OF GRASSE...
FROM THE FLOWER FIELDS TO THE FACTORY

** Texts in italics come from biographies.*

Too many roses ! Too many jasmines. Some degree of rarity is needed to create beauty...
And besides, these crops of flowers which cover almost the entire area between Cannes and Grasse...
There is perhaps something even more sacrilegious in the large-scale cultivation of jasmine...
The jasmine, this hypnotic flower, as the poet, Milosz, calls it...
Yes, we only seen it climbing a balcony, under the moon...
All these white stars fallen to earth like flakes of snow destined for decay, this entire milky way diverted to the factory, it's enough to break your heart...

Walking aimlessly through the town of Grasse...
For a long time we follow low, crumbling walls, walls behind which we sense the presence of some garden from A Thousand and One Nights, with its agaves, jasmines, fountains and its azulejos (blue wall tiles).
The multitude of worlds ruling over the multitude of flowers. The greenery studded with white jasmines. The earth balmy with their delicious nocturnal sigh.
The dominant scent was as profound and fine as the light. Two kinds of sweetness emerged : the light and the perfume.
The rose would give up its soul to the sun, the jasmine to the stars.
The jasmines, dark in the wet earth, were humbled by the abundant flowering of the rose bushes, the last of the flowers.

Francis de MIOMANDRE: "Grasse", 1928.

Originally from northern India, jasmine was probably brought back to North Africa and then to Spain by the Moors, as its name, *jasmyn*, Arabic in origin, would indicate.

Most certainly introduced into southern France by Spanish sailors around 1560, jasmine appeared in the area around Grasse as from the 17th century. Monseigneur Godeau, Bishop of Grasse in the 17th century, thus evoked the powerful scent of the jasmines and orange trees in letters to his Parisian friends.

It is estimated that by the end of the 17th century, 15 hectares were planted with jasmine. In the middle of this century, the picking season was fixed by the Council

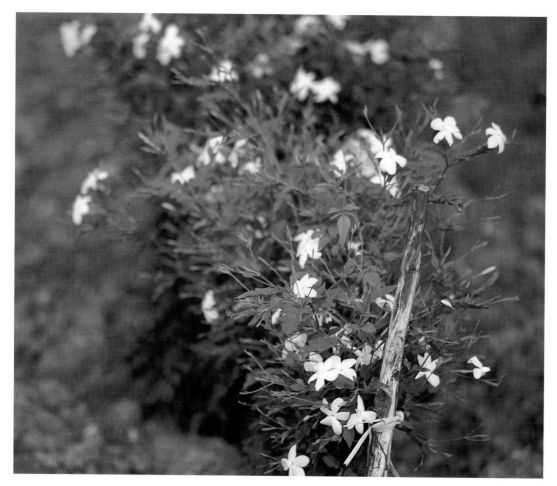

*Jasmine trained
over a wooden fence
Plascassier, summer, 1995
M.I.P. Archives*

of some twenty-one master glove dealers and perfumers of Grasse, the perfumers having the advantage of a monopoly on production.

Until the end of the 18th century, there were no special crops set aside for the perfume industry. The gardens of Grasse were sufficient to meet the demands of the merchant perfumers, providing them with jasmine flowers which they used to manufacture perfumes, powders, oils and perfumed fats. Large crops appeared later to supply the developing industry.

It was not until 1860 that jasmine began to be grown in the open fields. The construction of the Siagne canal provided a means of irrigation vital to the development of the jasmine plantations. Cultivation of it then spread beyond the town limits into the surrounding countryside where it reached its zenith a few years later.

For more than a century and a half, the cultivation and commercial processing of jasmine to obtain the absolute essential oil formed the monopoly of the Grasse region. At the outset, jasmine held a privileged position in the region: the plantations stretched from Vence (Alpes-Maritimes) to Seillans (Var). The amount of land under cultivation and volume of production, however, continued to decline. At present, the geographical area of this crop is demarcated by Bar-sur-Loup to the east and Grasse to the west (Grasse, Bar-sur-Loup, Chateauneuf-de-Grasse, Mouans-Sartoux, Pégomas, Opio, Auribeau and Peymeinade in the Alpes-Maritimes). In Var, the crop stretches from Fayence to Callian.

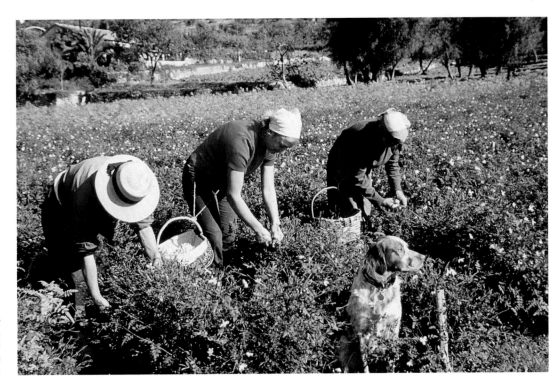

*Jasmine-picking
Eldée, Grasse region
c. 1950
Archives of the Musée d'Art
et d'Histoire, Provence*

* *
*

Jasmine belongs to the Jasmine branch of the olive family. There are almost 160 varieties used for garden decoration. Two white-flowered jasmines are grown in the main for the perfume industry:

– the large-flowered jasmine, *Jasminum grandiflorum L.*, used almost exclusively on the Côte d'Azur.

– The small-flowered jasmine, or common jasmine, *Jasminum vulgare L.* or *Jasminum officinale L.*

The large-flowered jasmine, or *Jasminum grandiflorum L., is* also called royal jasmine. Originating in Nepal, it was introduced to Europe around 1630. It was introduced in the form of a bushy, climbing shrub, growing to a height of 1 to 1.5 metres, often reaching 3 metres high. Its fairly large, glossy, oily white flowers, lightly tinged with pink inside, give off a very pleasant, sweet scent.

The common jasmine, *Jasminum vulgare L.* or *Jasminum officinale L.*, also known as wild jasmine, has smaller, less fragrant flowers. Hardier than the one above, it is used as stock for grafting.. It is found growing wild in the woods of lower Provence and the Italian Liguria. It is grown in Algeria, Turkey, Egypt, India, Tunisia, Bulgaria, Spain and Italy.

Since it is particularly sensitive to frost, jasmine can only be grown in the open ground in regions with a privileged climate. Even on the Côte d'Azur, the plants have to be earthed up, (i.e. covered), as winter approaches.

In France, the Alpes-Maritimes hold the monopoly on this crop with plantations located particularly in the areas surrounding Grasse.

The region produced 200,000 kg of jasmine in 1900, 550,000 kg in 1905, 600,000 kg in 1910 and more than a million kg in 1911, three-quarters of which were processed in the factories of Grasse.

Mouans-Sartoux, once the real centre of this crop, is situated below Grasse on a plain stretching out to the sea, bordered on one side by hills on which Plascassier stands, and on the other side by the Estérel chain. Plan-de-Grasse, Plascassier, Mougins, Magagnosc, Pégomas, la Roquette and Peymeinade are also important centres.

There are a few plantations at Bar-sur-Loup, le Cannet, in Cannes, Vallauris, Antibes and Nice.

This flower, invaluable in the perfume industry, demands a great deal of care and attention as well as special treatment for it to be able to develop on the Mediterranean coast.

The choice of land is one of the basic factors which come into play in the quality of the jasmine. It seems that the aspect, exposure and permeability of the land are of prime importance. Jasmine grows well at a height of 300 or 400 metres. Royal

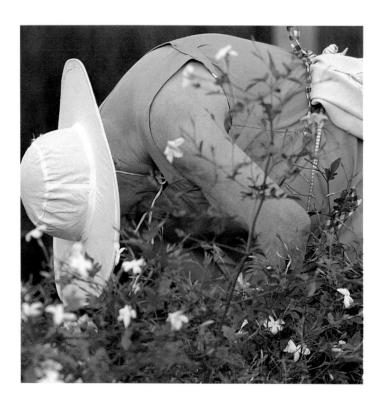

Jasmine-picking
Plascassier, summer, 1995
M.I.P. Archives

jasmine only prospers in permeable, well drained, widely irrigated and very sunny soil. Indeed, rotting tree roots can give jasmine "muffle", locally known as "root rot", a fungal disease caused by fungi asphyxiating the plant at the base. The ideal terrain for growing jasmine has for a long time been land laid fallow or else sown with cereals.

To plant a jasmine field, the land is trenched in September to a depth varying between 60 cm and 1 metre. In the same way the irrigation channels are banked up and the stonework laid. The stock is planted around February and March. This consists of cuttings of wild jasmine or jasmine officinal, *Jasmin officinale L.*, called "cavillons"* by the growers of Provence, which usually come from the Vesubian

* Translator's Note: "cavillons" = unknown and not traced. Could it be a spelling mistake in the French for "cavaillons", i.e. "balks", usually associated with vine cultivation?

valley or the Italian Riviera. These cuttings are prepared by cutting them at 40 cm long and keeping them in gravel throughout the winter to protect them from frost. These stocks are planted with the aid of a round iron dibble 0.6 cm in diameter and 40 cm long, helved on one side and pointed on the other side. A vertical hole 25 to 30 cm deep is dug into which the balk is sunk allowing only the upper two buds to peep out. The soil is firmed in well around the cutting.

In the following spring, grafting is carried out. This long, hard, delicate work generally requires the involvement of specialists. The long branches of the stocks are removed with secateurs, and only the main stem is kept, an incision 2cm long is made by a woman's hand. The graft is generally made on a "slit". A second worker, sitting on a small seat, pushes the graft right into the slit. A woman follows and ties the whole thing with a braid of raffia. A fourth worker with a hoe completely covers the graft with light soil. In 1929, a team such as this was paid 160 to 180 Francs per day, during which it grafted approximately 2000 jasmines.

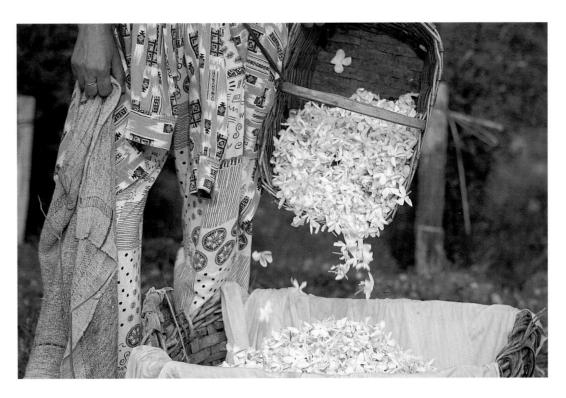

After picking
Plascassier, summer, 1995
M.I.P. Archives

In February to March, when there is no further danger of late frosts, the roots are laid bare, exposing the base of the plants.

Before the buds appear, a woman prunes the branches, which have remained above the earth throughout the winter and have frozen, with secateurs.

To make the flowers easier to pick later on, the plants are nailed up when that year's branches are well developed. They are attached to wires stretched out at a height of 35 to 40cm on iron or wooden posts at 4 metre intervals.

From around mid-June until October, irrigation work is carried out by laying drains along each row of jasmine.

Hoeing and weeding removes grass and flattens balls of earth at the roots of the plants.

Finally, as the cold weather approaches in October or November, the plants are earthed up to 30cm high to protect them from frost.

Newly grafted jasmine generally flower in the same year, but only at the end of August, whereas old jasmine flowers from the beginning of July.

* *

*

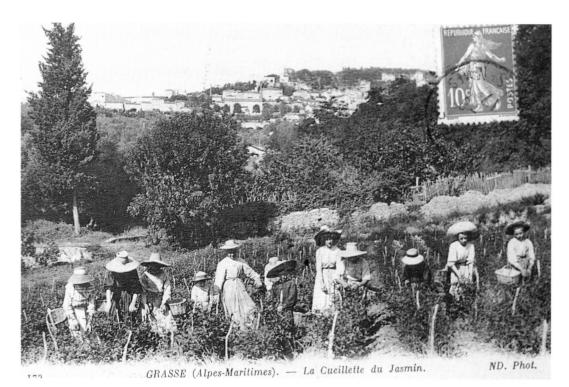

GRASSE (Alpes-Maritimes). — La Cueillette du Jasmin. ND. Phot.

Jasmine-picking in the Grasse region, early 20th century M.I.P. Archives

In the first half of the 20th century, fields of flowers stretched as far as the eye could see.

"Before, everyone would go and pick. No-one said "we're going to pick the jasmine", but "we're going to pick. How many flowers have you picked? The blossom wasn't very good. The blossom was wet". The jasmine harvest was wonderful. It took place in Grasse, in Mouans Sartoux, where the adjoining plots of land merged into one vast field. As you passed you would embrace the fragrance which would stay with you for the rest of the day"

There were two types of farm in the region prior to the economic crisis of the 1930s: the industrial concern and the family farm. They showed the geographical source of the work force employed.

The oldest industrial concern was established over vast areas, a few of which belonged to the industrialists (Chiris, Camilli,...) growing different crops of flowers. They were run by tenant farmers who grew and picked. At harvest time, the industrialists called on temporary immigrant workers whom they took over completely: special buildings, crèches, and canteens were at their disposal.

These first industrial concerns gradually disappeared after the economic crisis of the 1930s. Only more modest concerns already in existence survived, differing from those first concerns not only in size but also in that they grew one crop:

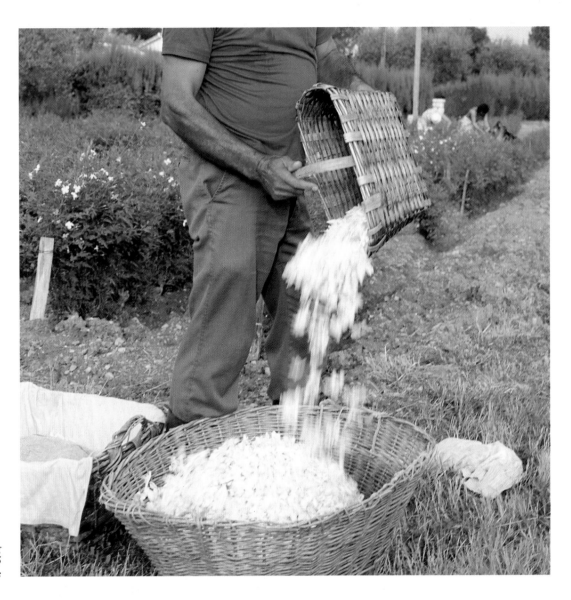

*After picking
Plascassier, summer, 1995
M.I.P. Archives*

rose or jasmine. Local women and children in the main were recruited as workers. Only this type of concern survives today in the region.

"During the week it was mainly the women and children, but on Sundays, the men came to lend a hand. This was also an opportunity for the girls to meet young men."

The women came on foot and in groups to their place of work.

"Everyone came down from the village on foot to St-Basile where Mr Camilli had an enormous property which stretched as far as the eye could see. On the way to the fields, we all hung on to each other, from the tiniest baby to the oldest person."

The women were helped by their children who did not go back to school until October. Furthermore, there was a great deal of flexibility over school.

"At that time, we would not go back to school until 1st October. If the harvest was not over, however, the Mayor would sign an authorisation note and we would not to return to school until the 15th."

You could begin to pick as soon as you were three years old and continue until you were over eighty, if you were in good health.

"I think I was born in jasmine. I began to pick when I was three years old. My

mother had given me a little box in which I put the few small flowers I had picked. At the age of five, I already had my own basket."

Following the Second World War, most of the big local families were no longer involved in harvesting the jasmine. Producers therefore increasingly used foreign workers. To obtain one kilo of jasmine, the number of flowers picked would vary between approximately 8000 at the beginning of August and 14000 at the beginning of October. A harvest of 800,000 kg of jasmine required approximately 3000 people to work throughout the flowering season. A third of this workforce was recruited from the farms. The rest, i.e. approximately 2000 women and children, came from the towns (Grasse, Nice, Cagnes...) and surrounding villages (Mougins,...), and from Italy.

"Many Italian families came to gather the jasmine. In the Alpes-Maritimes, the flowers were picked each year by workers recruited in Italy by the horticulturists.... I have the honour of being able to inform you that my department, as in previous years, has been overwhelmed by applications to hire Italian workers to pick flowers, these workers being exclusively female."

A large number of Italian families came particularly from the Coni province for many months, going from village to village, hiring themselves out for the grape harvest then the olive harvest.... But the difficulties added by the Italian government of the time in preventing its farm workers crossing the border, made recruiting this workforce problematic, at a time when the growth in the jasmine plantation involved greater demands.

But Italy was not the only centre for recruiting workers for the harvest. In France, the mountain villages of the Alpes-Maritimes and the towns (Grasse, Cannes, Nice...) also provided them.

While workers were not always easy to find, the producer was not always in a position to pay for them either. He had, in fact, to pay for the pickers' travel costs and provide accommodation for foreigners.

These factors, added to the harvesting costs, meant considerable outlays which the "small" producer found difficult to bear.

* *
*

The harvest began around 14 July and ended in the first fortnight of October, traditionally on the 10th, although flowering would continue for a great deal longer. The flower picked at the end of October, however, is less fragrant and therefore fetches a lower price, while the flower picked in November has almost no fragrance at all.

Picking began each day at dawn, including holidays and Sundays, and sometimes even by the light of the moon when there was a full moon. For it to be done well, it had to be completed by mid-day, because the perfume of the flowers diminishes in the heat of the day. Unfortunately, since it had become difficult to recruit pickers, smaller numbers of them very often had to toil in full sun until 3 or even 5 o'clock, sometimes even until dusk on the days when the flowers were in blossom in order to be able to pick all the flowers in full bloom. This often meant eight to nine hours' work at a stretch.

"We would get up very early, at 4 o'clock in the morning. I was living in Mougins at the time. We all hung on to each other on the way to the fields. At 5 o'clock, the owner handed out the squares. Each family had its own square. There was a lot of jealousy, of course, because sometimes others had more beautiful squares with

▶ *After picking in the Grasse region, c. 1950 M.I.P. Archives*

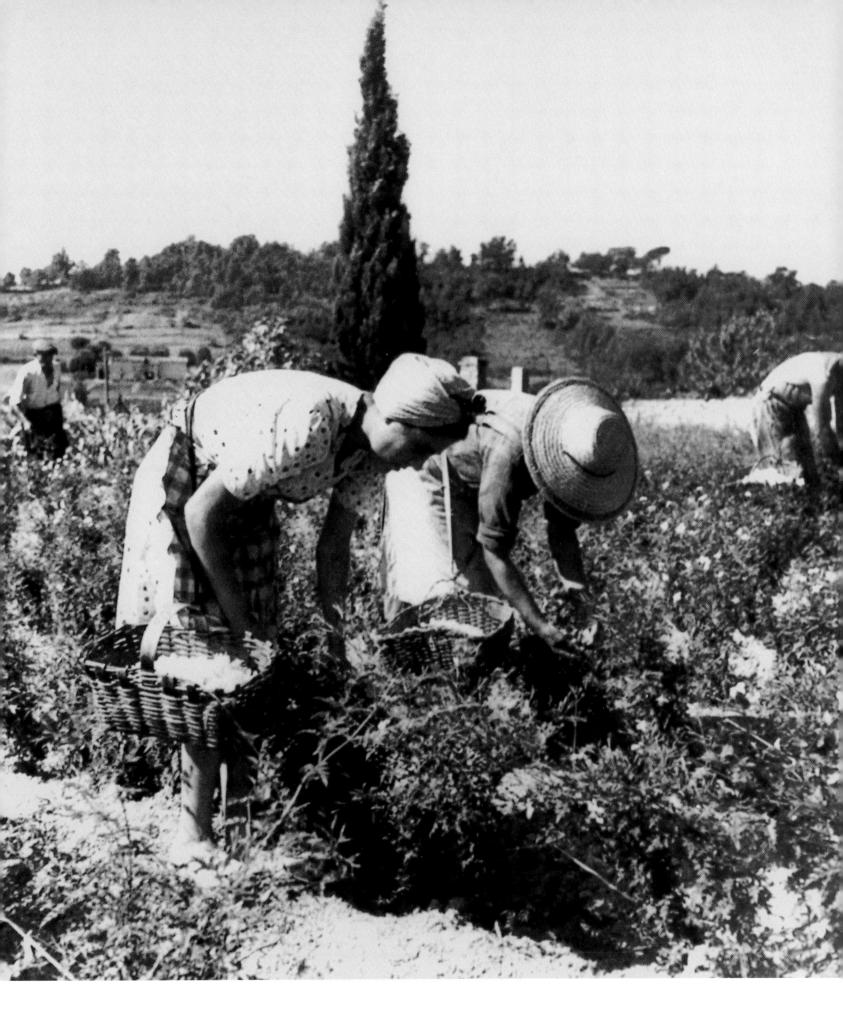

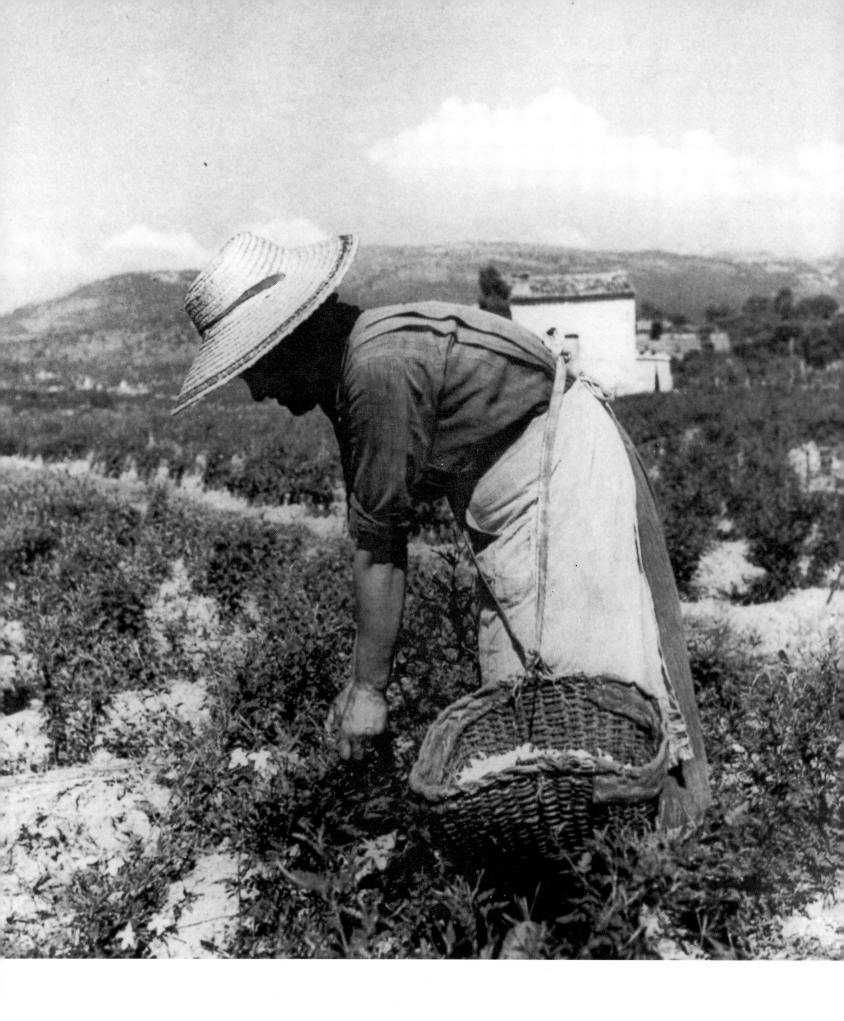

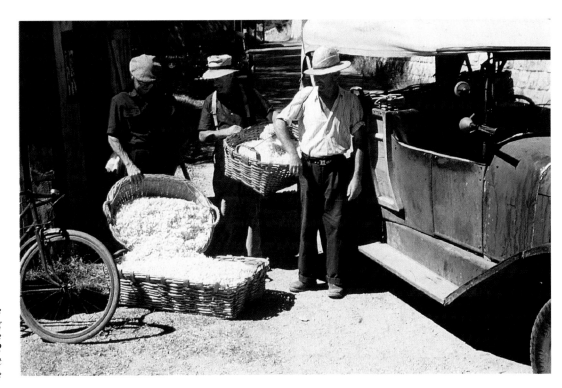

► *Baskets of jasmine*
awaiting weighing
Quartier Saint Mathieu, Grasse
Eldée,1952
Archives Musée d'Art et
d'Histoire de Provence

more flowers. Around 8 o'clock, the owner called us with a conch and we were allowed to rest."

"We did not take 2 hours for lunch and a rest at mid-day. We did not know about the 8-hour day. Jasmine flowers are not plums; they are light like feathers. You have to keep your nose to the grindstone to make an average wage. Working in the factory, it was all hands on deck. Fine, agile fingers are needed to pick the flowers."

"On the way there, I slept as I walked. I clung on to my grandmother's arm and I would not open my eyes more than three times on the journey between the village and the field. And in the evening, I would sleep again whilst spraying my feet in the ditch, feeling the water reach the end of the row."

"Once, we were in a field of jasmine and a couple of people passed by on the road. They asked us whether we slept in the jasmine because they had passed early that morning and we were already there, and they passed by again late in the evening and we were still there."

There were no Sundays or rest days; every day was needed for picking.

"It's very tiring work, because you have to bend down all the time, and then there are no rest days. Every day, from July to October, you have to get up early. It's difficult, but I like it."

"You know, the pickers who have picked all their lives end up with rheumatism. When it rains or has rained, the earth becomes very muddy, you drag the mud along on your feet and that slows us down, so we often prefer to take off our shoes."

Despite the back ache, sun, rain, cold, sleepiness, the pickers have very happy memories of this work.

"You work for yourself and also earn for yourself. If you want to work very quickly, you can. If you would rather slow down, you can do that too. Yes, I like

◄ *Facing page and overleaf:*
After picking
in the Grasse region,
c. 1950
M.I.P. Archives

it because there are lots of people, you talk together, you laugh.... In any case, I would rather pick than be a cleaning lady. Now, they come and fetch us in a van every morning. This year the harvest began late. People are complaining that there are no more flowers, but I managed to find some."

"Now, with family allowances, the schools go back before the end of the harvest and wages are adjusted, there are fewer and fewer people who want to pick. The young now have their own jobs so there is no advantage for them in picking. It must also be said that it's very hard. You have to get up very early, and at the end of the season, it's cold in the mornings. Often, in October, we make up a fire to warm ourselves up because our hands are paralysed with the damp. When it is very damp, we put on an apron to protect ourselves. It's best when the weather is muggy and warm because then there are a lot of flowers."

<div align="center">* *
*</div>

Picking, a long and delicate operation, was done only with both hands because the flowers are very fragile and must be picked one by one by the stem to prevent the petals falling off.

"When you pick, you must not take the buds, otherwise the jasmine will not flower the following day. It's the agility of the fingers which counts. I, myself, pick with both hands with the basket attached to my waist. I make little fistfuls but, when there are a lot of flowers, I manage to make 7 to 8 kg on a good day."

Once picked, the flowers were laid in a basket holding 100g attached to the waist by a piece of string. An experienced picker would manage to take 25 flowers in each hand before emptying it all into her basket. This required flexibility of the fingers only acquired through habitual use. A good picker thus managed to harvest 500 to 800g of jasmine an hour, equal to 6 to 7 kg of flowers per day.

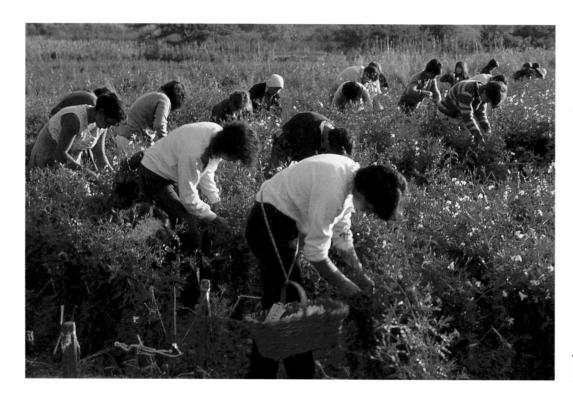

*Jasmine-picking
Grasse Region, c. 1980
M.I.P. Archives*

When the basket was full, the contents were emptied into a large basket placed in the shade and covered with a damp cloth to prevent the flowers drying out. Each picker had her own baskets.

"We were dressed differently. The traditional dress of the picker was the square wicker basket attached to the waist, white stockings to prevent insect bites and a hat kept on by a pin stuck in to the bun. We would wear boots. At this time, a girl should never look tanned. It was a disgrace. Pallor was a symbol of wealth. So we would cut up our stockings and tie them round our arms to prevent them going brown. Occasionally we would hang a large handkerchief under our hats to protect the nape of the neck."

Sometimes the women laid their flowers in their aprons, the edges of which they lifted up and fixed to their waists to form a pocket, full of jasmine, making them look "pregnant with flowers". But the flowers were crushed and took on a brownish tint with the heat of the body, which made them lose their value. The preference therefore was to use the basket for picking.

When the flowers were wet, they were spread out on sheets laid on the ground to dry in the sun. Dried flowers fetched better prices from the perfumers than wet flowers. Each picker had her own sheet.

At the end of the day, the producer weighed the baskets and noted down the weight in a book showing the number of kilos gathered. There was one basket and one book for all the members of the same family. The harvest season over, the producer calculated the total weight of jasmine picked by each picker and paid her.

Then the flowers were poured into large oval baskets covered with linen, each containing 15 to 20 kg, which the producer delivered to the factory where the jasmine was immediately spread out for processing without delay. The picturesque jasmine gatherer of yesteryear, bringing her harvest to the factory herself in a basket "sitting on a cushion" balanced on her head, has disappeared today.

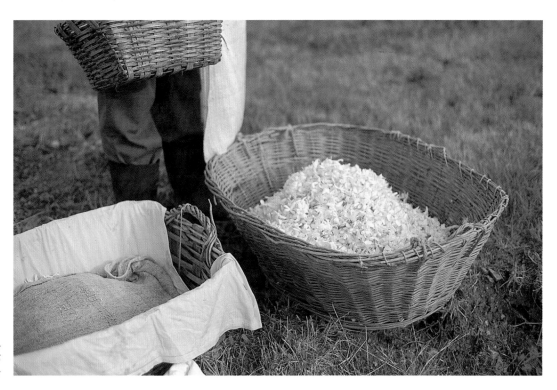

Basket of jasmine
Plascassier, summer, 1995
M.I.P. Archives

The producer carried his flowers either directly to the factories, as the producers of Grasse did, or to the brokers or agents who collected the flowers picked on the property and sold them on to the factories in return for payment. He could also deliver his own production to the cooperative. Producer co-operatives, which appeared around 1920, had their own factories for distilling or processing flowers.

Each producer received a notebook in which the quantities delivered every day were recorded. Payment was made at the end of the harvest. Some factories also used vouchers which they issued to their suppliers. Once paid, the growers paid the pickers and their children, when there were no other members of their family present, having deducted their own expenses and profits.

* *
*

How much did a jasmine picker earn?

How were the producers paid?

In 1921, a serious dispute arose between the perfumers of Grasse and the producers. An article in the "Voix du Peuple" (Voice of the People) summarised the situation.

"For 30, or even 40 years, the orange flower, rose and jasmine producers would take their goods each year to the factories in our town. For how much? The producers never knew. Led like a flock of sheep, they would arrive each day in single file, and deliver their daily pickings, the weight of which was written in a book as big as your hand. At the end of the harvest, they would receive the number of kilos of flowers brought to the factories, calculated over X units, which was the going rate. Who fixed the rate? Who discussed it? The perfumers themselves. They, and they alone, fixed the price of starvation, which these gentlemen were pleased to pass on to the producers. None of these producers had the right to protest, grumble or discuss. It was so much, full stop".

Prices varied enormously from one year to the next, high when there was a poor harvest, low when there was a rich one. Thus the price of a kilo of jasmine, for example, fell from 4.25 F in 1906 to 2.50 F in 1907....

There were two possible strategies for the growers: either to sign a contract with a perfumer over one or several years at a fixed price, whatever the annual rate, or to reject any contract and depend on the rate. The result of the first was that flowers were regarded as "under contract", and the second, that they were regarded as "unrestricted" flowers.

Some years favoured the first, prices having collapsed, and others were to the advantage of the second, prices having soared. Whatever the rates, however, solidarity between neighbours worked: since nobody knew in advance the exact quantity a field would produce each year, part of the harvest of the unfortunate person was transferred across to the fortunate neighbour.

In other words, if the unrestricted flowers were bought at a higher price than those under contract, the "unrestricted" grower took it upon himself to deliver part of the harvest of his unfortunate contracted neighbour under his name, and vice versa.

Round about 1920 producer co-operatives appeared, which attempted to influence prices and they had their own factories for distilling or processing flowers. This enabled them to avoid the loss of part of the harvest if the perfumers were not able to increase the output of their machines when their stocks were full. These

▶ *Facing page:*
Above:
Little girls
picking jasmine
Grasse Region, c. 1920
M.I.P. Archives

▶ *Below:*
The jasmine-pickers
Grasse Region,
c. 1920
M.I.P. Archives

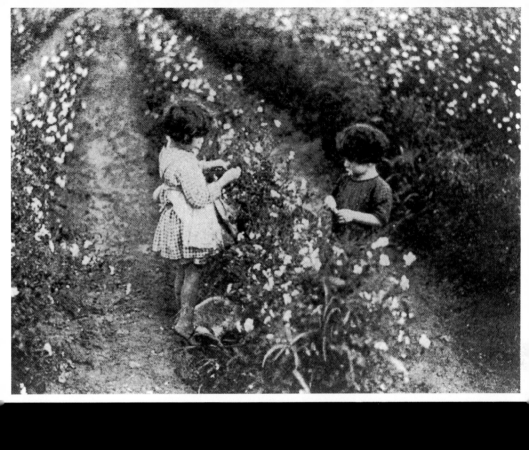

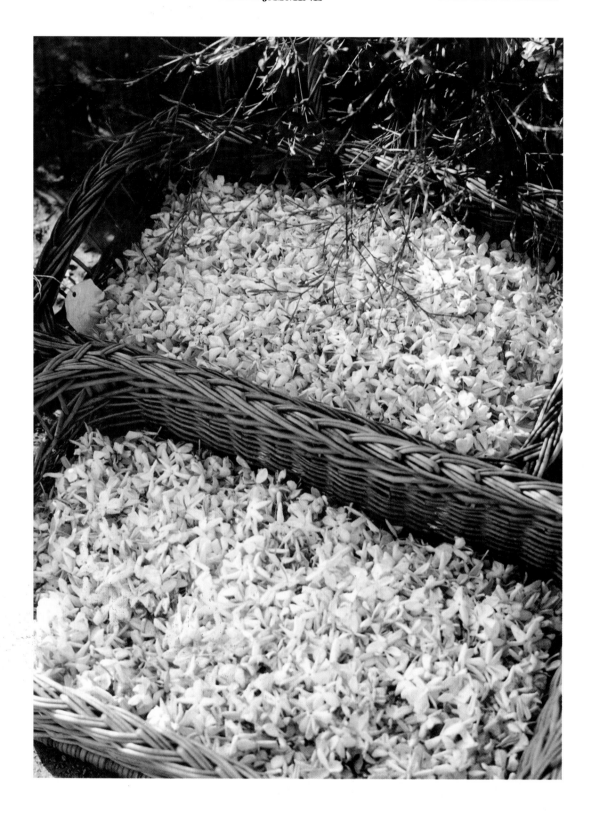

Above and facing page:
Baskets of jasmine
Grasse Region,
20th century
© André Martin, Chanel

structures also made it possible for them to withstand any disputes. There were two prices at this time, one for the "cooperative" flower, and the other for the so-called "unrestricted" flower. The cooperatives, of course, fought for their flowers to be paid at a higher rate than the rate for the unrestricted flowers.

August was a favourable month for workers to fight. All the harvests were in full swing. Starvation wages were the cause of lightning strikes and disputes from 1900, in view of the fact that the flower harvest could not wait....

How did wages develop in the perfume industry of Grasse? We know nothing about them. The little information collected from that time is from periods of industrial disputes which the workers' press repeated.

In August 1900, the "Voix du Peuple" (Voice of the People) reported that workers from several factories went on strike on Sundays for an increase of 25 centimes per day. At this time, Bertrand Brothers, for example, employed thirty or so workers: 18 earned 1.50 F per day, the others, 1.25 F. A delegation of three workers met with a refusal from the employers, which triggered a general strike.

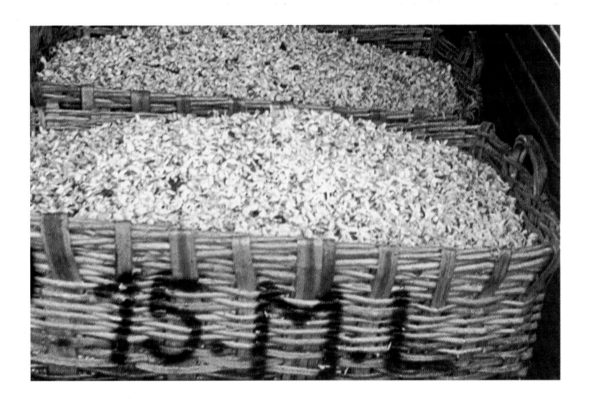

Lautier gave in by proposing 1.50 F for everyone. Roure-Bertrand-Dupont followed suit. The Chiris and Pilar Brothers factories were spared by this strike through a system of quarterly bonuses allocated according to the volume of work carried out. They thus made sure that a flexible workforce was present when needed.

In August 1907, the "Voix du Peuple" (Voice of the People) was talking again of a wages strike. Male workers were paid 2.50 F per day and received 50 centimes more, whilst the female workers who earned 1.25 F per day only received 25 centimes more. They were probably not included in the 1.50 F for everyone obtained in 1900.

Everybody worked between 15 and 16 hours a day, with no weekly day of rest. It was not until March 1908 that the wage earners obtained one rest day a week, having demanded it from the union of Perfumer Distillers, the Ministry of Employment and National Insurance, and the mayors of the towns producing flowers for the perfume industry.

"Clocking off books" from the Etablissements Chiris, held by the staff manager in 1933-35 show us that the situation hardly changed. A 52-year old woman working in the alcohol workshop earned 1.65 F per hour; another 18-year old employed in the factory shop earned 1.70 F; a third 55-year old woman, the crèche supervisor, 1.60 F. A 19-year old man, unskilled, earned 2.80 F; his elders, 50- or 60-year-olds, unskilled workers in the fractional distillation shop, were paid 3 F or 3.10 F. A lorry driver earned 4 F. The trainee driver, on the other hand, was given only 1 F per hour.

In 1933, for many reasons associated with the crisis of 1929 as much as with the decline of certain aromatic products, the Etablissements Chiris made massive redundancies. On the 1st of December, 59 waged workers, 34 men and 25 women, were dismissed for economic reasons. The shock was a violent one; the event remains etched in people's memories.

Under these conditions, it is not surprising that perfume firms in Grasse unanimously followed the general strike of 1936.

In the 1930s, Chiris employed as many women (48 %) as men (52 %). Growing jasmine and processing its flowers to obtain the fragrant essential oils have particularly been subject to important changes in the course of the 20th century. Numerous geographical shifts occurred associated with economic and political events.

* *

*

The quality of the concrete, the fragrant paste which was the result of processing the jasmine, depended on the harvest, on the summer's weather conditions, and on the month and even the hour when the flowers were picked.

Processing the jasmine flowers was the most delicate problem of the aromatic raw materials industry.

"Enfleurage" (cold saturation), the standard treatment, gave a better output in terms of quality and quantity. In fact, the fragile nature of the jasmine excluded the use of traditional processes such as maceration or distillation. It was the process which most faithfully restored the scent of the flowers.

"Enfleurage works in a manner closest, relatively speaking, to the olfactory tract itself of the mucous membranes of our noses, where the surfaces absorb the sweet-smelling fragrances given off by the flower one is smelling for a very short period of time. Our olfactory tract does not suddenly make contact with all the main aromas of the flower by breaking open fragrant cells, and the fat used in the saturation process also works like the mucous membranes by taking in their sweet-smelling fragrances, almost without being in contact with the flowers, up to the point where these fragrances are no longer given off" (Parfums de France).

An essentially female workforce carried out this cold saturation work.

They began by preparing the fat, a mixture of beef tallow and lard, washed, poured off on to canvas and cast in moulds. It was heated in a steam still until completely melted, and diluted with benzoin and alum. The fat was poured into

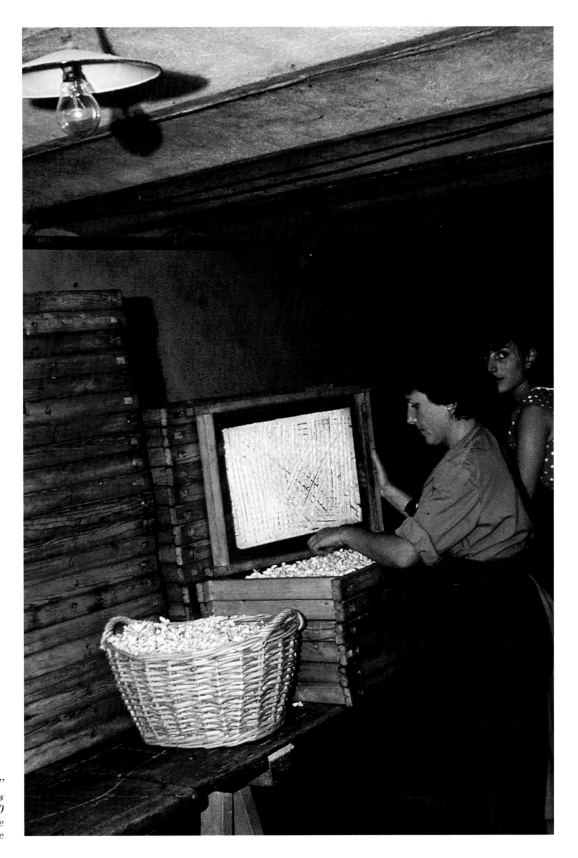

*The "enfleurage"
(saturation) process
Grasse, Eldée., c. 1950
Archives Musée d'Art et d'Histoire
de Provence, Grasse*

copper kettles, and stirred until it thickened and was set aside until the time when it was used in wooden containers covered thereafter with tinfoil. This work kept the perfumery busy for a large part of the month of May, at orange blossom time.

"Cold saturation on lard hardened by beef tallow was carried out in a large, noisy, frame handling room. No machinery. Nothing but manual work on tooling wooden and glass frames".

Then came the framing, with frames made up of plates of glass of 50 to 60cm on each side mounted in a wooden frame. Towards the end of June, the fat or pommade was spread on each side of the pane of glass then streaked with a wooden comb to harden it before the first consignments.

"A woman would smear the white fat over the glass with a steel spatula. With a five-pronged box-wood fork, she would cross-comb it to give it a greater area of contact with the flowers.

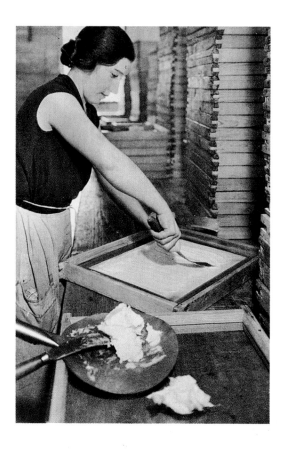

◀ *Cold saturation process,*
Chiris works, Grasse
The frames are first coated with fat which
captures the jasmine perfume.
Early 20th century
M.I.P. Archives

▶ *Facing page: Above:*
The flowers are stuck into a thin layer
of fat
Chiris works, Grasse
Early 20th century
M.I.P. Archives

▶ *The flowers are removed*
from the perfume-saturated fat
Chiris works, Grasse
Early 20th century
M.I.P. Archives

The women workers used to draw these lines with their nails. The wooden tool copied their former movements with fingers parted, movements claimed for a long time to be irreplaceable".

The first flowers would arrive at the factory around the end of July, where they were immediately sifted. All the leaves, all loose or damaged petals, crushed, old and damp flowers had to be removed to avoid fermentation.

The flowers were then taken to the enfleurage (saturation) workshop where they were arranged on frames, 50 to 100g to each frame. As soon as they were stacked, they were hermetically sealed on top of each other. Thus the perfume exhaled by

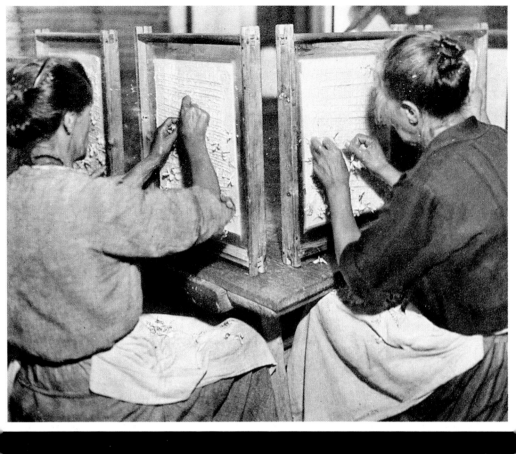

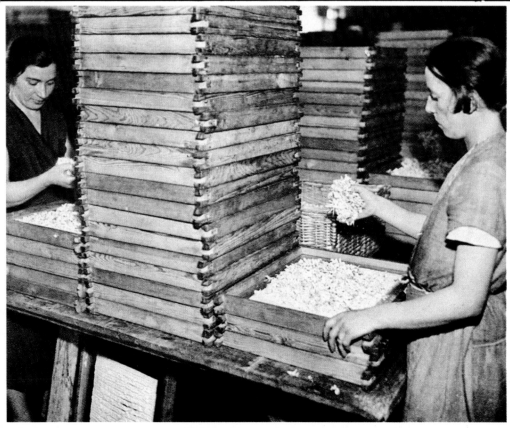

the part of the flower not in contact with the fat was absorbed by the fat of the frame above.

Piles of 30 to 40 frames were made in this way. One hundred frames constituted a workshop where approximately 10 women worked. After 24 to 48 hours, shedding began by tapping the frame casing against the table several times so that most of the flowers fell down. The others were removed by hand with finger-tips. Every day, in order to renew the area of contact of the fat, it was streaked with a wooden, large-pronged fork before further shedding started. This operation was repeated until the fat was saturated.

"Perfection in the speed at which they worked was not demanded of them, but they were asked to finish the quantity of flowers brought in from the gardens within the day".

The fat was then removed from the frame with a wooden spatula. They would then wash the pommade which had been thinned with alcohol. In a mixer fitted with an agitator, the fat was added, diluted by its own weight in alcohol, and it was all mixed together for 24 hours consecutively. After decanting, the excess alcohol was collected and cooled in an ice box to solidify the residual fats. The alcohol used for washing was then filtered and set aside. The perfumed alcohol was distilled in a vacuum. The residue, soluble in any proportion of alcohol, was kept. This was called the absolute frame or pommade.

This enfleurage (cold saturation) technique involved a large number of frames (80,000 at Chiris, 70,000 at Roure), and the use of a large workforce. One worker tells how in 1930 up to 200 seasonal female workers were taken on to do this work.

"Enfleurage was a catastrophe. To prevent the fat melting, it was carried out in the factory cellars. Mr Chiris had forbidden anyone to cut the plane trees down in the courtyard so that the shade from them would help keep the cellars cool. On days when it was very hot, however, the fat became too soft. When the frames were turned over, the petals stuck together and had to be removed by hand, but you would remove part of the perfumed fat at the same time. Then the bosses would shout. Everything was sticky. It wasn't funny when there was a whole day of frames being turned over".

The complexity of the work and the low productivity explained why this process was abandoned in the 1940s in favour of extraction by light solvent.

The fragrant product of the flower was obtained by using a light solvent in an extractor. This solvent, impregnated with perfume, was then processed to isolate the floral product or concrete obtained in this manner. It was a mixture of a fragrant and wax product which had to be removed. The concrete was then mixed with the alcohol to obtain the absolute, a pure product, at the end of production.

2.5 kg of concrete, which would provide 1.5 kg of the absolute, was obtained with 1000 kg of flowers.

The value of one kilo of the absolute today is estimated to be 80,000 francs.

* *
*

Grasse, the only region producing jasmine until 1925, has seen its production gradually decline.

In 1925, Grasse was producing 1000 tonnes of flowers.

In 1931, the effects of the world economic crisis pushed world production down to 700 tonnes.

In 1965, production barely reached 300 tonnes and less than 100 tonnes in 1980.

Only twenty-five tonnes are processed today in Grasse.

Italy, Algeria, Morocco, Turkey, India and, for a few years now, Egypt have also become large producers of the concrete and absolute. Egypt supplies more than two thirds of world production today.

This change in production is mainly due to the 1974-75 economic crisis and foreign competition (disparities in labour costs, social security contributions, price of products).

Egypt, at present the largest producer of jasmine, operates a workforce with lower social security costs. The length of operation is longer than in the Grasse region.

Cultivation is carried out there at greater heights than the grafted jasmine.

Grasse jasmine is sometimes mixed with the imported absolute in order to reduce its high selling price. Some perfumers, however, still demand the pure absolute of Grasse, famous for its great delicate features.

Land pressures and the lack of labour are also a significant factor in the decline of the region's jasmine crop.

We are forced to note that today the Côte d'Azur revolves more around tourism than agriculture. The decline in jasmine cultivation can also be attributed to the fields being abandoned in favour of the towns, as in the rest of France.

Nevertheless, the remarkable quality of Grasse jasmine due to the micro climate, the composition of the soil and the nature of the plants grown (grafted jasmine) may help to preserve a small volume of local production.

Valérie BIA,
Ethnologist

Marie-Christine GRASSE,
Curator of the Musées de Grasse

BIBLIOGRAPHY

ALLIO R.: *Da roccabruna a Grasse. Contributo per una storia dell' emigrazione aunuse nel S.E. della Francia*, Rome, 1994.

AUNE L., SABATIER A.: *Grasse, portrait d'une ville provençale*, Nice, éditions Serre, 1981.

BIA V.: *Contribution à l'histoire du travail des femmes: la cueillette des fleurs dans la région grassoise de 1900 à nos jours*, dissertation, Aix-en-Provence, Faculty of Arts, Sept. 1993.

VARIOUS: *Cent ans d'inspection du travail dans l'industrie des parfums*, exhibition catalogue, Nice, Direction Départementale du Travail et de l'Emploi des Alpes-Maritimes, (Labour Administration of the Département of the Alpes-Maritimes) 5-25 Nov. 1992.

FONTMICHEL H. de: Histoire de la parfumerie grassoise, *in Histoire de Grasse et de sa région*, Roanne, éditions Horvath, 1984, p. 123-147.

HAMP P.: *Le Cantique des cantiques*, 2 tomes, Paris, NRF Gallimard, 1922.

JEAN C.: *Monographie agricole des Alpes-Maritimes*, 1920.

LOUVEAU G.: Le Jasmin, *in la Revue des Marques*, Paris, April 1936.

MOTTET: *Les plantes à parfum dans la région grassoise*, thesis, Nice, Faculty of Arts, 1968.

PERRIN E.: *La parfumerie à Grasse ou l'exemplaire histoire de Chiris*, Aix-en-Provence, Edisud, 1987.

PEYRON L.: Un siècle de production de plantes à parfums dans le sud-est de la France, 1889-1989, *in Parfums, Cosmétiques, Arômes*, Oct.-Nov. 1989, no. 89, p. 97-113.

RASSE P.: *La cité aromatique. Pour le travail des matières odorantes à Grasse*, Nice, éditions Serre, 1987.

ROLET A.: *Encyclopédie agricole. Plantes à parfums et plantes aromatiques*, Paris, 1918.

La Voix du Peuple, years 1900, 1907, 1920, 1921.

JASMINE, a creeping shrub, the flower of which is also well known for its sweetness and aroma. It is one of the products of the plant kingdom which can be used most successfully in our operations, but a little experience is needed to do this.

Anonymous, *Chimie du goût et de l'odorat ou principes* - J. A. IM., 1755.

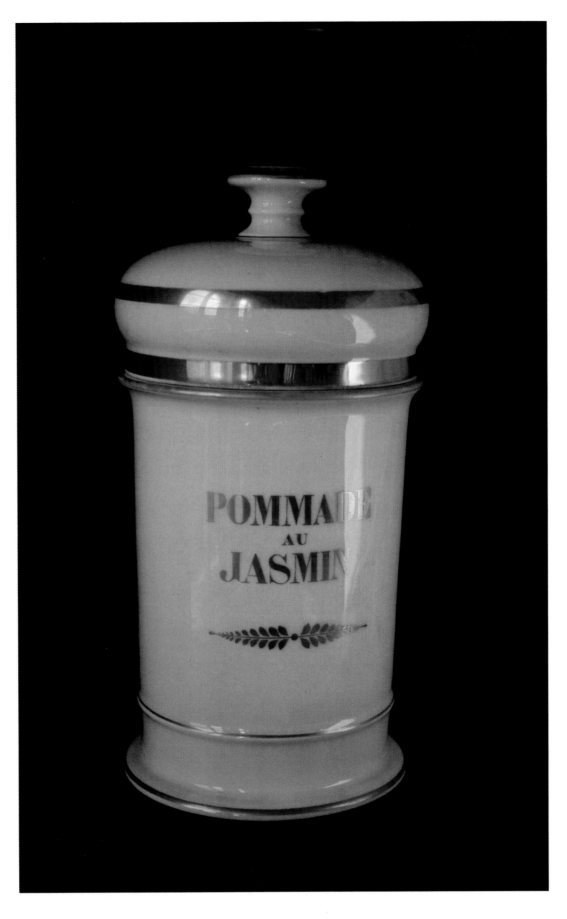

Apothecary jar
White porcelain
20th century
M.I.P. Collection

*Jasmine eau-de-cologne
label Paper
7.7 cm × 5.4 cm
c. 1980
M.I.P. Collection*

JASMINE IN GRASSE FROM ITS ORIGINS TO THE PRESENT DAY

J asmine for the perfume trade in Grasse – an epic three to four centuries, the origins of which are still unclear. Its history can be divided into two major periods, the major turning point of which was at the end of the 19th century. Its establishment is first noted in the Grasse region with flowers being processed on a small scale for the perfume trade until around 1860, when the plantations began to be extended. At the end of the 19th century, changes in the production of scent extracts and industrialisation took place, followed by a decline in the middle of the 20th century.

But what has become of the production of flowers and jasmine extracts in the Grasse context, past and present? Is the typical nature of the Grasse concretes and absolutes still a reality and on what basis? Can we talk about the soil (*terroir*) of the jasmine in Grasse?

* *
*

Various production methods for extracting perfume were used in Grasse.

Until the end of the 19th century, one of the oldest processes used in the 17th century was definitely the process consisting of the flowers simply being in contact with a quantity of starch, chalk or talc, i.e. of powder, in a closed container arranged in alternate layers. The jasmine flowers were sifted and renewed in succession.

A second method used in the 16th and 17th centuries consisted of placing 12 to 15 pounds of oily fruit such as ground almonds and jasmine flowers on separate beds in a well sealed, tinplated box for three days. The batch of flowers was renewed several times. The almonds, then pressed, provided the perfumed oil and a paste which was dried and used, iris powder having been added, to protect the hands.

There were several alternatives to contact without immersion in vegetable oil (olive, sweet almond oil...), use of which was widespread in the 17th century.

There were wooden frames fitted with hooks which held cotton sheets soaked in oil, over which the flowers were strewn which were renewed 10 to 12 times each day. The sheets were then detached, folded into four, then pressed.

Layers separated by cotton impregnated with oil and jasmine flowers were place in an earthenware dish. The operation was repeated several times after the cotton was separated and squeezed and fresh flowers added.

An inch or so of purified lard was poured into two tin dishes, then the jasmine flowers were placed on top. One dish was then placed on top of the other. The same process used glazed dishes from Vallauris.

A more modern method with animal fats, the so-called enfleurage (cold satura-

tion), made a timid appearance in Grasse at the beginning of the 19th century and became a real monopoly of Grasse half a century later.

From the beginning of the 19th century, wooden frames fitted with a pane of glass were used, on which a 6mm layer of a perfumed fatty substance was spread, made up of a mixture of lard and beef tallow. The area of contact was increased by drawing grooves. The jasmine flowers were placed on the layer of fat, and the frames piled on top of each other. In the middle of the operation, the fat was turned. From earliest times, jasmine perfumed fat has been combined hot with small quantities of orange, then amber, musk and vanilla flowers, the equivalent of a perfumery preparation. It was not until the middle of the 19th century that industrial enfleurages in Grasse become raw materials. This very delicate method, however, required a considerable amount of equipment and number of staff, which involved serious economic problems and would in the end condemn it.

Distillation with the water vapour of the flowers exhausted up by enfleurage provided distilled Jasmine flower water.

At the end of the 18th century, oils saturated with alcohol were processed to obtain the distilled essential oils. From the beginning of the 19th century, however, Grasse had strong alcohol and mechanical means of preparing washes of perfumed fats and oils, with two successive extractions providing the first and second infusion.

The washes were concentrated in steam-heated evaporators. A little later, the washes were exposed to frost (in refrigerators) and evaporation methods improved by using the vacuum.

Other processes were also used with immersion contact at variable temperatures.

The perfumed fatty substance made up of animal fats, two parts lard, one part mutton fat and one part beef tallow was melted in a tinplated container. Their weight in jasmine flowers was then added, and was held for one to two hours at 50-70C in kettles called *bugadiers* (barrel churns?) placed in steam stills. This was maceration. It was then passed on to the linen cloth, pressed to a pulp and the batch of flowers replaced five or six times.

The oil and the flowers could also be processed in the steam stills or the sun for two to three days, then tightly expressed, and the infusion renewed twelve to fifteen times. Vegetable oils were obtained by doing this.

The process of distillation in water vapour is a very old one and the output very low. The jasmine flowers filled a Florentine flask with a correctly adjusted cowl. They simmered on a low heat and a small amount of water was collected and redistilled two to three times with further quantities of flowers.

* *
*

It is difficult to evaluate the importance of flower and jasmine extract production prior to the 20th century. The fashion for perfumed leather introduced in the 16th century rapidly became successful in the 17th century. Gloves, waistcoats, doublets, shoes, belts, boxes and fans were coated with perfumed fats and oils perfumed with jasmine. But the revolution dealt the Grasse perfume trade a considerable blow. The Grasse perfumers, however, were so skilful that their luxury trade only suffered a brief eclipse. Whereas the 18th century had undergone a transformation in the scope of trade, from glove-making to perfume manufacture, the 19th century witnessed a transformation in production developing from a cottage industry to a major industry, giving Grasse world dominance in the perfume industry and

Jasmine-scented pommade
label Jean Giraud fils
Paper
5.7 cm × 7.8 cm
Early 20th century
M.I.P. Collection

its raw materials. In 1856, 80 tonnes of jasmine flowers were processed, and two hundred tonnes in 1900.

With the industrial revolution came new methods of processing flowers. The first commercial attempts to process flowers with volatile solvents date back to the beginning of the 19th century with sulphuric ether, carbon disulphide and methyl chloride. But it was with petroleum ether, which had become available through the work of Naudin and Massignon, that a genuine local extraction industry was established.

In 1873 Roure submitted concrete essences of flowers extending to the absolute essences to the Universal Exhibition of Vienna. But it was in 1898 that Léon Chiris set up the huge extraction workshop nicknamed the "Mosque" which remained a model of its kind for a long time. The machinery was fixed, the flowers being immersed in the solvent. Rotating machinery was manufactured. The Garnier basket wheel was highly successful in 1902. Then the Bondon wheel (1929) represented a certain degree of progress, as did the Bondon-Dumont-Tournaire rotating extractor later on.

We shall not go into the operating details, except to say that generally the jasmine flowers were exhausted over three, ten- to twenty-minute periods at ambient temperature. The 'miscella', decanted then filtered, were concentrated in two successive operations at low temperature to give a concrete which still contains small quantities of residual solvent.

Average outputs : 0.26 % to 0.30 % (Garnier)

0.35 % (Bondon)

0.26 % to 0.30 % (fixed).

Concretes dispersed in alcohol at 45-60°C are filtered (Buchner,...). Filtrates are chilled at approximately − 10°C, then filtered again. They are exhausted three

times in succession. Modern filtering systems have evolved from the fixed type (Buchner) to the rotating type (Tournaire,...). They are concentrated under atmospheric pressure, then in a light vacuum, maintaining a low alcohol content to prevent losses of light constituents. Average absolute outputs vary between 52 and 63 %.

Flowers processed in volatile solvent, then steam blasted, can be used to improve the soil, re-extracted with benzene, or subjected to enzyme treatment of the glucosides present, to obtain "bioessence".

Residue waxes from the production of absolutes have been used for a long time in the soap trade (Marseilles) or again for making reconstituted concretes and absolutes.

From the great extracts of the last century, cold saturation continued to be successful throughout the first few decades of the 20th century, whilst hot maceration was gradually abandoned.

Concentrates of perfumed fats were prepared by processing the perfumed fats with alcohol in barrel churn refiners, called agitators or waltzers, also used to process concretes.

Before 1900, almost all the flowers were saturated, then the proportion gradually diminished:

20 % in 1929, 12 % in 1951 and very little, practically speaking, from 1960 onwards.

* *
*

Label for IANINA JASMIN
jasmine-scented eau-de-cologne
Paper
3.7 cm × 2.4 cm
First half of the 20th century
M.I.P. Collection

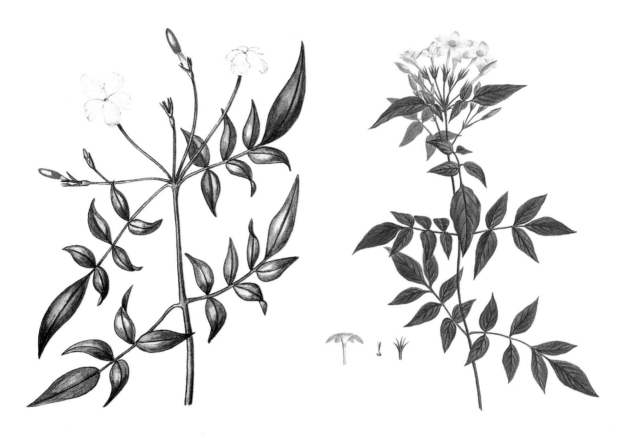

Jasminum grandiflorum *Jasminum officinalis*

Jasminum grandiflorum L. grafted on *Jasminum officinalis* is grown on all the hills around Grasse as far as Vallauris to the east, and the confines of the Var to the west. The plant's needs are great, both in terms of the climate, the soil and the growing methods (irrigation, dressings,...). It is also highly sensitive to root rot.

The flowers are fragile. Considerable precautions must be taken when picking, as in storage and transport. As the nature of some of the yields of extractable fragrant products (mindol,...) depends on the time they are picked, it has not always been easy to harmonise these requirements with those linked to the members of staff responsible for picking and extraction.

The average yield per 100 square metres in 1976 was 28 kg for the Alpes-Maritimes and 13 kg for the Var. There are several reasons why production fell regularly, amongst which are the relocations of plantations and extractions, often inspired if not actually carried out by the industrialists of Grasse.

Here are a few surface areas of plantations at various periods:

1930 : 800 hectares
1966 : 200
1970 : 89.3
1976 : 51
1978 : 44
1980 : 42

Sixty-three per cent of jasmine producers (238 in 1980) are located primarily in the towns of Grasse, Chateauneuf de Grasse and Bar sur Loup, then Mouans-Sartoux, Mougins, Pégomas, whereas the Var has very few:

1975 : 389 producers,
1976 : 279 producers,
1977 : 238 producers.

The two types of flower supplies of the factories are under contract or unrestricted, with delivery to the factories broken down as follows in 1968 :

producers : 122 tonnes
brokers : 111 tonnes
cooperatives : 80 tonnes

In 1960, 538 tonnes of jasmine flowers were processed in Grasse by the following firms, in descending order : CAL, Laborma, Robertet, Roure, Bertrand Bros., Chauvet, Chiris, Tombarel, Lautier, Cavallier, Bernard Honorat, Schmoller and Bompard, Argeville, Mane, Sozio, Payan-Bertrand, Bruno-Court.

The costs of the so-called jasmine concretes of Grasse vary significantly depending on the year, demand and the manufacturers.

* *
*

Triple extracted jasmine perfume label
Honoré Payan
Paper
11.8 cm × 10 cm
c. 1910
M.I.P. Collection

PRODUCTION OF JASMINE FLOWERS IN THE GRASSE REGION

YEAR	TONNES	YEAR	TONNES
1856	80	1961	569
1900	200	1962	474
1906	600	1963	328
1914	600	1964	341
1923	700	1965	292
1924	950	1966	320
1925	800	1967	300
1926	1050	1968	317
1927	1500	1969	270
1928	1000	1970	267
1929	750	1971	192
1930	1800	1972	155
1931	1550	1973	266
1932	1300	1974	170
1938	700	1975	186
1941	634	1976	75
1942	662	1977	129
1943	712	1978	105
1944	428	1979	125
1945	651	1980	120
1946	770	1981	77
1947	831	1982	73
1948	585	1983	62
1949	789	1984	42
1950	725	1985	36
1951	699	1986	30
1952	678	1987	23
1953	615	1988	25
1954	674	1989	32
1955	756	1990	35.5
1956	690	1991	19.3
1957	615	1992	23.5
1958	666	1993	25.6
1959	590	1994	26
1960	538	1995	26

The olfactive comments on the jasmine absolutes of Grasse by a few of our great perfumers are very flattering:

– exceptional, light, powerful note, fresh as a plant and blackcurrant, tenenol, absolute orange flower leaves note,

– not very much indole or anthranilate,

– light, powerful note, very faithful as it grows in a pleasant, harmonious, stable manner,

– lovely, unequalled quality,

and finally a more prosaic comment: "it is to the perfume industry what butter is to cookery; the effect obtained with margarine is never the same."

Jasmine has been an undeniable historical, socio-economic factor for Grasse for very many decades. It is THE "flower".

Based on a family farming system, it was directly or indirectly the livelihood of a large part of a population smaller, of course, than it is today.

The fragrant atmosphere of Grasse and its countryside during the summer months until the 1980s is an unforgettable memory for those who experienced it.

Jasmine was an integral part of local folklore shaped by the "jasminade" (jasmine festival), the battle of the Jasmine flowers, the real ones!... spraying with water perfumed by jasmine (reconstituted, of course!), election of a jasmine queen,...

Jasmine was an integral part of regional literature: Godeau, Mistral, Arnaud, Suskind, Hamp (the Canticle of Canticles) as well as of painting and decoration: Gallimard's picture, earthenware cups awarded each year to the best jasmine flower picker, yellow-bottomed dishes decorated with jasmine from Marseilles in the 18th century,...

Dr Louis PEYRON,
Grasse

Essence of Jasmine
label R. Sornin & Cie.
Paper
7.8 cm × 7.6 cm
Early 20th century
M.I.P. Collection

62

JASMINE FROM THE GRASSE REGION AND ELSEWHERE

Despite all the crises, all the economic challenges, all the competition from synthetic products, the perfume of the jasmine flower remains one of the essential elements, and sometimes the main pillar in the structure of the greatest perfumes.

From Chanel No. 5 in 1921 through to Arpège, it has been found in luxury perfumes such as Patou's *Joy* or Christian Dior's *Diorella*.

A member of the jasmine branch of the olive family, the *Jasminum* genus is very old and, apart from the types which have disappeared today, consists of a hundred or so mostly Asiatic species. The perfume industry uses white large-flowered Jasmine (*Jasminum grandiflorum Linnaeus*) and the Sambac Solander Jasmine.

Highly sensitive to the low winter temperatures of the Grasse climate, it was only able to become acclimatised in Provence due to the growing method of grafting on to common jasmine or jasmin officinal (*Jasminum officinale Linnaeus*) with small white, very fragrant flowers which grows easily in the southern regions of Europe.

Growing the large-flowered Jasmine and processing the flowers commercially to obtain fragrant extracts was the exclusive monopoly of Grasse and the surrounding area for more than a century and a half (end of the 18th century to the first quarter of the 20th century). After the First World War, however, in the 1920s, this crop spread to other parts of Europe and the world, to Liguria, Sicily and then to Calabria in Italy, Andalucia in Spain and the shores of the eastern Mediterranean, to Egypt, Algeria, Morocco and Tunisia, and more recently to Turkey (Antalya), South Africa, the Comoros and very recently to southern India.

Short-lived tests were carried out in Guinea, Greece and Brazil. China (Yunnan, Canton Province and central China) has become a large producer of extract of Jasmine flowers over the last ten or twenty years, but from different species to the *Grandiflorum*.

The two methods of growing Jasmine which, in Grasse and the temperate climes, are subject to winter frosts, are the grafting of the large-flowered Jasmine on to Jasmin Officinal as stock and in exotic countries with a gentle winter climate, the direct ungrafted cultivation (direct planting). Other methods have been tried as an experiment: growing Jasmine under a cloche in conditions which take into account the influence of photoperiodicity associated with temperature on floral induction. Out-of-soil growing tests to obtain young plants resistant to root system attack by root rot (*Rosellina necatrix Hart*) have been carried out by the I.N.R.A. in Antibes. The multiplication of clones by micropropagation and micrografting has been studied by the Montpellier Histophysiology Laboratories. In India, direct propagation assisted by growth regulators has been used to produce young plants for planting out in the open field. Finally, the use of stocks other than Jasmin Officinal may be envisaged.

Grasse, which was still ranked top after the First World War in the production of

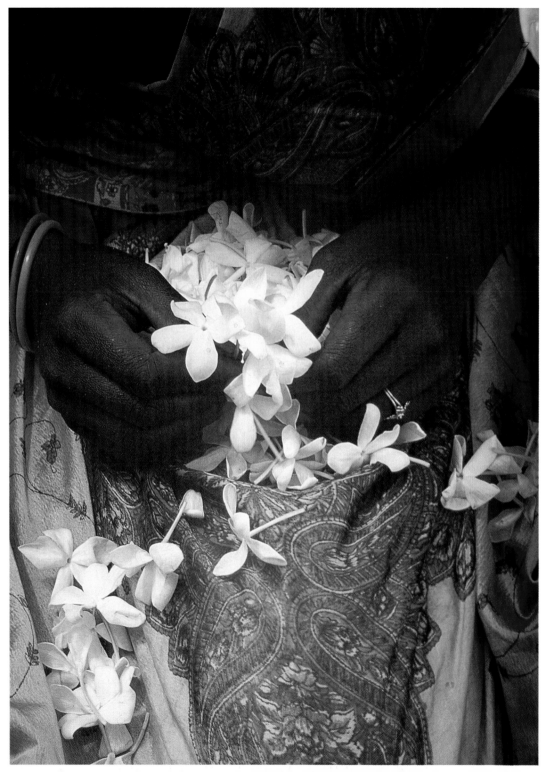

Jasmine flowers and their extracts, saw this production decline slowly at first, then more rapidly, particularly over the last few years.

In 1925, the production of Jasmine flowers in Grasse was 1000 tonnes, equal to three tonnes of hexane concrete. In 1930 this production reached 1800 tonnes of flower, i.e. more than five

tonnes of concrete. In 1965, thirty-five years later, flower production was 300 tonnes, i.e. 0.9 tonne of concrete. There was a particularly significant drop in the 1960s when Italy and Morocco to begin with, then Egypt, started to produce. Today, if we refer to the figures of the Syndicat Prodarom, production in Grasse is no more than 25 tonnes, equal to 70 kg of concrete.

The spread of Jasmine cultivation throughout the world and industrial processing for producing extracts for the perfume industry in Egypt, Morocco, India and China, has meant that quantities of Jasmine absolute being marketed have multiplied three or four times. It is no longer the traditional regions of the South of France, Algeria and Italy, however, which are producing them. There has been a geographical diversification, reconcentrated to begin with in the Nile delta, then very recently in southern India, in the states of Mysore and Coimbatore.

Can it be said that Grasse Jasmine is now condemned to disappear? If this is the case, it would be a void for our industry in Grasse painfully felt by all those who lived through that great period when hundreds of jasmine plantations filled the Grasse countryside, and the flowers arrived at the factory in a fragrant atmosphere of flowers freshly picked by skilful, extraordinarily agile hands.

Present knowledge of the constituents of Jasmine flower extracts, through the contribution of the latest analytical research techniques, fixes the number of chemical compounds contributing to the flower's odour at 260. Analytical techniques of the odour given off by the flower throughout its life have revealed the characteristics of Jasmine from different geographical sources. The Grasse source is characterised, for example, by the relationship between two constituents of the absolute: benzyl benzoate and isophytol. It is also differentiated from exotic sources by its low indole and benzyl acetate content and higher Jasmenoid contents: methyl jasmonates, lactone of jasmine... giving it a fruitier, less animal note.

The quite exceptional odour of the absolute of Grasse Jasmine makes it a unique product due to its olfactive qualities, irreplaceable in luxury perfumes. Were it only for this, there would always be a corner of land in the Grasse countryside where this marvellous flower, the town's symbol, would grow.

Jean GARNERO,
Chemical Engineer, Grasse

*Jasmine flowers India,
c. 1980
Private collection*

*Poster advertising Grasse
as the World Capital
of Perfume
Paper
60 cm × 50 cm
c. 1975
Municipal Library
Collection, Grasse*

JASMINE, THE SUPREME PERFUME

Whilst the rose is the queen of flowers, jasmine is the king of perfumes. It has been a symbol in Grasse of the perfume industry of the whole world.

Since the idea came into being of extracting the perfume of these small white flowers with which the bush is scented, jasmine has continued to be the main weapon of the great perfumes. What would Coty's *Chypre*, Chanel's *No. 5*, Patou's *Joy* and many others have been without jasmine?

The jasmine generally grown by the producers is the *grandiflora* variety which gives big flowers in greater numbers per hectare, and therefore more essential oil. Wild jasmine, however, also found in the steep valleys of the Alpes-Maritimes, gives much smaller, but finer scented flowers. It is the young plants of this wild jasmine, called "cavillons"* which are grafted with the *grandiflora*. From the outset it can be seen that the yield, i.e. the quantity, took precedence over quality.

Jasmine cultivation in Grasse has undergone many ups and downs in the course of time. At the beginning of the century, they would cut short their children's and their elders' sleep so that they could go and pick "the flower", as jasmine was called for short, at dawn before school. This early morning picking had the advantage of processing the jasmine flower before it was impaired by the sun. This

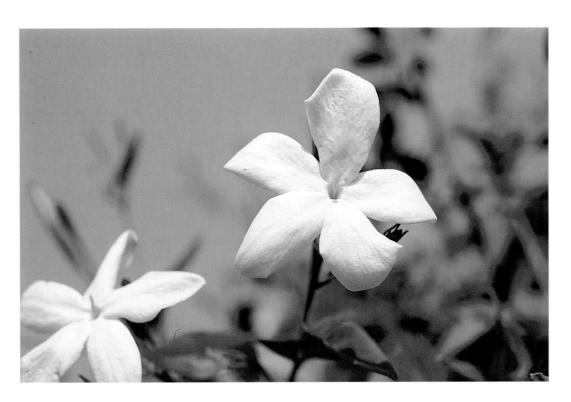

Jasminum
Grandiflorum Linnaeus

harshness disappeared in time and we have known planters who would pick in the afternoon and deliver the flowers the following morning!

This negligence was aggravated by washing the flower in petroleum ether too many times (three times in general) and for too long (half an hour). Over the last fifteen to twenty years the process has been improved by reducing the time these flowers remain in the petroleum ether to a few minutes, the exhaustion of the perfume being almost instantaneous. Since heat is the enemy of perfume, the petroleum ether is chilled in hot countries to +5 or +6°.

The olfactive value of the jasmine comes from the fact that it is flowery, fresh, exuberant and reasonably tenacious. It is the natural product par excellence. Not only does it bring all these qualities in to a composition, but its pliability, its versatility and solid base also make it universal.

The so-called "head space" method of analysis has revealed a much greater number of constituents of the odour of the flower itself. Before the war, scarcely half a dozen of them were known. Today a thousand are known to us. This has obviously made it easier to reconstitute this odour through synthesis. If a strict, sensible classification is made of these known constituents, very fine reconstitutions largely comparable with the natural product can be obtained which, despite all the precautions mentioned above, suffers a great deal during processing with light solvent.

In the latest contemporary perfumes, the influence of jasmine is considerably reduced by the heavy use of chemical substances, particularly in the musk scented notes which cover not only the floral odours, one of which is jasmine, but also many other delicate notes which help to express the general olfactive form. There is no doubt that things will develop in the future.

Edmond ROUDNITSKA,
Perfumer-Creator, Art & Parfum, Cabris

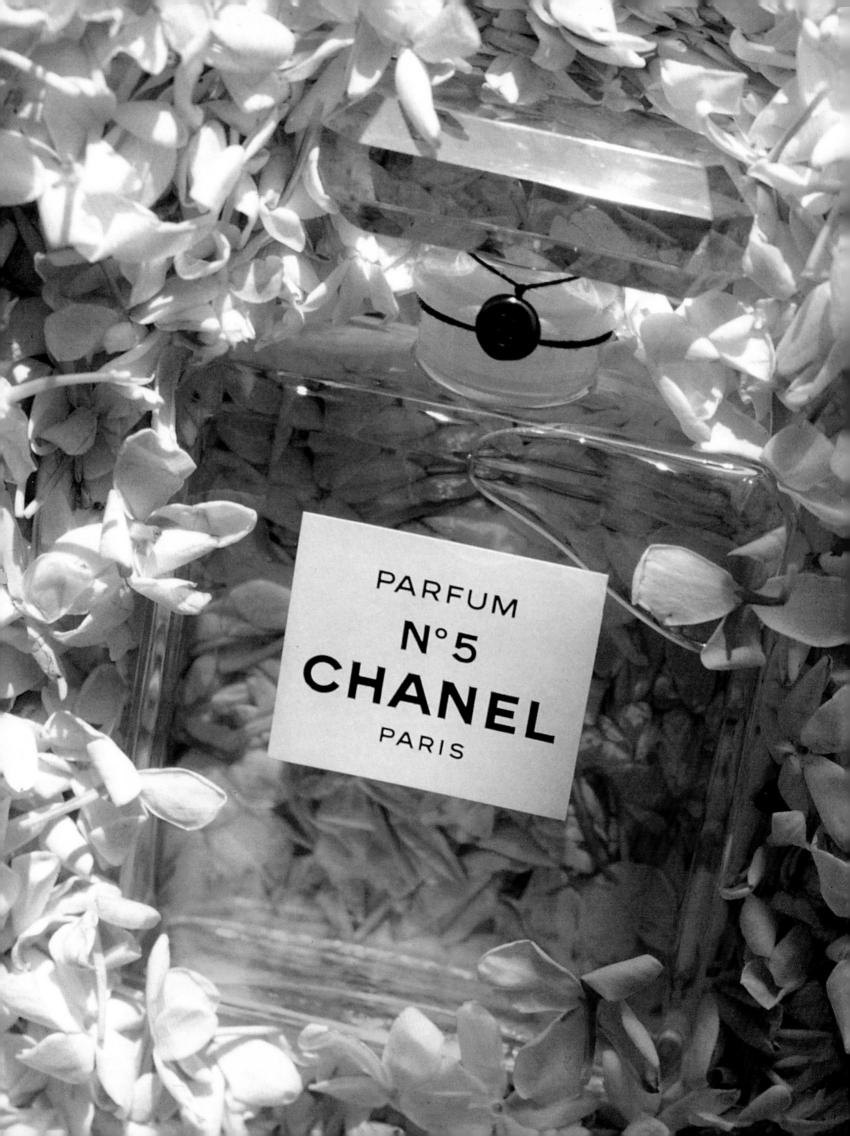

THE QUALITIES OF GRASSE JASMINE

Jasmine, flower of Grasse.... What magic does it exert over you as a Creator of Perfumes? Why Grasse Jasmine?

I am CHANEL's Perfume Creator, which has become a very special position, since CHANEL is one of the last perfume houses to have an integrated perfume creation department when most perfume companies today sub-contract the creative work.

No. 5, created in 1921 by Ernest Beaux, is the Perfume which, for me, symbolises Grasse Jasmine, with its incomparable scent.

Jasmines at present come from different sources such as Italy, Egypt, Morocco, India and China. From a botanical point of view, Grasse Jasmine is of a particular kind, being a grafted Jasmine, making it smaller from the point of view of the size of its young plant than all the exotic Jasmines, and its olfactive qualities constantly surprise me when I compare them with those of foreign Jasmines. It has an unequalled volume, depth, and richness. To me it is the reference Jasmine against which all the others are measured.

Does not Jasmine, the natural product par excellence, suffer today increasingly from competition from synthetic products which reconstitute its odour?

Jasmine reconstitutions are much better than they were when I started in the job. But even if there is constant improvement, the best reconstitutions will always remain the poor cousins compared with the most mediocre of the natural Jasmines. On the other hand, the chemists, who are constantly pushing the analysis of Jasmine forward, have been able to find and provide the Perfumers with quite interesting constituents which modify, express and relay the harmonies of Jasmine.

What did CHANEL have in mind when it acquired the monopoly of certain floral products in the Grasse region?

Jasmine is one of the most difficult crops to maintain. The cost of floral products is directly linked to the cost of labour, and Jasmine is a flower, the labour costs of which are the highest. You must remember that a good picker collects 500g of flowers per hour when in one hour she would collect 6 to 7 kg of Rose de Mai. It takes 7000 to 10,000 Jasmine flowers to make 1 kg of flowers and 350 kg of Jasmine flowers provide 530g of Jasmine absolute. Throughout the years, the Jasmine crop has grown abroad where labour costs were lower, and the various Jasmine qualities available today provide so much choice.

No. 5 was created in 1921 with Grasse Jasmine. The only one in existence at the time, it obviously made good sense scrupulously to respect the qualities of an enduringly successful formula.

Since the quantities produced in Grasse since 1921 continue to decline, it seemed

Facing page:
Bottle of Chanel No. 5
Clear glass, 1921
Photo by Chanel

71

important to us a few years ago now to stop this fall and maybe increase production to ensure our needs were met. It was then that SOTRAFLOR came into being in Pégomas, where 20 to 25 tonnes of Jasmine flowers a year are processed for CHANEL, this particular Jasmine being exclusively reserved for Parfum No. 5.

For other CHANEL Perfumes which contain Jasmine, we are going ahead with what we call "communelles" (blend of Jasmines from different sources) so as to locate a constant quality each year which does not restrict us to a soil (*terroir*) which is too limited.

You are a Perfumer, someone with whom the public at large are unfamiliar. What is your background?

My parents came and settled in Grasse where I studied. I did not come from a perfumery background at all, but Grasse is the heart of the profession. I had many encounters there. After an Arts Degree in Aix, I had the opportunity of trying my hand at this job for a company which was looking for perfumers for a branch in New York. I am one of those who thinks that this job is learnt, as are most jobs, and that you only know later (again as in most jobs) whether you have any talent for it. So I learned the job in Grasse, worked in New York then Paris and finally at CHANEL. Working at CHANEL enabled me to do this job in the best place, i.e. at the cross-roads of tradition and the most up-to-date methods, in a company where one of my duties is to perpetuate the craftsman's dimension of the Perfumer's job.

Jacques POLGE,
Creator of CHANEL Perfumes

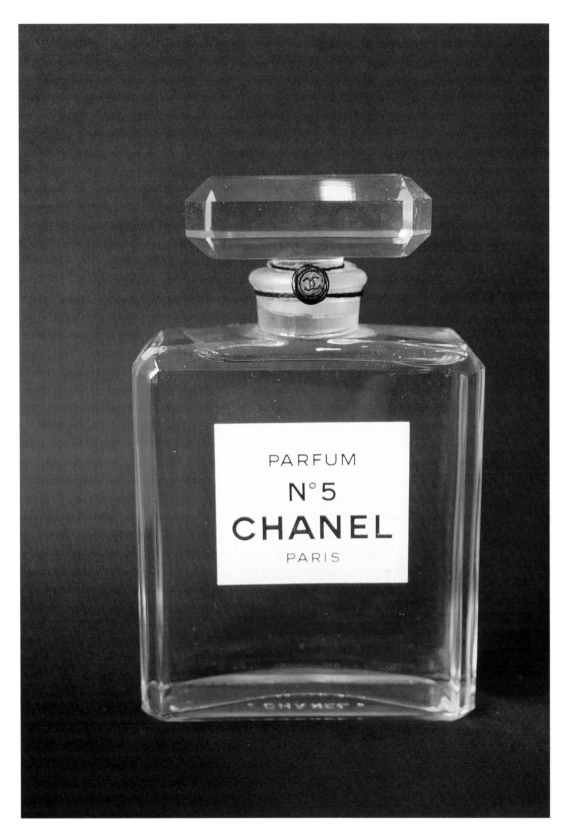

Bottle of Chanel No. 5
Clear glass, 1921
M.I.P. Collection

Label for Lubin perfume
"Jasmin du Nil"
Paper
4 cm × 2.7 cm
c. 1930 M.I.P. Collection

A CENTURY OF PERFUMES BASED ON "JASMINE"

Never be a bad smell
for an entire kingdom, my child,
Hold your head up high like the jasmine
in the midst of all.
Le Hussard sur le toit, Jean GIONO

As a child, at dawn, I would pick the jasmine flower, a transparent porcelain white, one by one between the thumb, index and middle finger, intoxicated by its light, green, gentle scent. Around mid-day, the last chalky white petals were heavy with the warm scent of the orange flower. The forgotten, yellowing flowers exhaled, the evening having arrived with deep, animal, musky scents. Whilst its olfactive composition varied with the rhythms of the hours of the day, its character did not change, and I was able invariably to recognise the scent of the jasmine. After all the discoveries of this century on the chemistry of odours, the 1980s and the use of the "head space" techniques will demonstrate that the composition of the scent of the flowers varies according to the circadian rhythm without changing character. This proves that the character and the form of an odour are linked to the materials from which it is composed, more than to the proportions used. Hence the plunge was quickly taken to match the fragrance and form of a perfume. Between intuition and reason I shall evoke a century of jasmine and perfumes.

Whilst the exhibit most appreciated among the curious exhibits displayed at the Universal Exposition of 1900 was the retrospective of make-up and toiletry boxes and perfume bottles from Victor Klotz's collection, the owner of Edouard Pinaud Perfumes, visitors were able to see perfumed fat concentrates from firms in Grasse in the chemistry pavilions alongside natural essences, those new absolute essences with scents so reminiscent of the plant.

Extracted directly by light solvents, they were displayed by the firms of Antoine CHIRIS and ROURE BERTRAND and Son, which earnt them the exhibition's grand prize. The chemical products, however, were the major revelation of the French factories (factories of the Rhône and the Loire) and particularly the German factories (Schimmel and Haarmann and Reimer), which copied the perfumes of plants and fruit, such as benzyl acetate with the odour of jasmine and banana, an artificial perfume as it was called at the time, discovered in 1855 and later identified in the composition of the distillate of the perfumed jasmine fat by Hesse and Muller around 1900.

Suspended between their past and the future, perfumes oscillated between simple, figurative or abstract, fanciful fragrances. Some perfumers offered ready-to-wear perfumes or more traditionally, perfumes one created oneself, as in the shop "A La Corbeille de Fleurs" (The Basket of Flowers) of the perfumer, Houbigant. He had 200 scent extracts such as acacia, banana tree, jasmine, ylang ylang, and a

few imaginary, fanciful perfumes to perfume pockets, handkerchiefs, lace, gloves, ribbons and above all the skin! Coty, the newcomer to perfume, only offered twenty fragrances in its 1912 General Price List, broken down into perfumes for handkerchiefs, eaux de

toilette, face powder, sachets, brilliantines and soaps. Simple fragrances such as *Cyclamen, Muguet* and *Corsican Jasmine* created in 1906, which became Colette's favourite perfume, as well as fanciful perfumes such as *L'Origan, Chypre, Ambre Antique* (1905), archetypal of the harmony of jasmine, rose, amber and vanilla.

The perfumers were Arys, Bichara, Caron, Coty, D'Orsay, Grenoville, Guerlain, Gellé Brothers, Houbigant, Lenthéric, Lubin, Millot, Mury, Molinard, Pinaud, Pivert, Rigaud, Rosine, Roger et Gallet, Violet and Volnay. When they did not have a factory in Grasse providing them with washes of perfumed fats, concentrates of perfumed fats, essential oils, resins and new products such as concretes and absolutes, they were visited by the bosses of the Grasse companies, who presented them with the year's quality products. They also chose synthetic products. Since these often had a violent odour, the new chemist-perfumers invented the raw materials, blends of ten or so substances which evoked imaginary scents or copied simple fragrances. Fragrances of flowers such as Chuit et Naef's Jasminia, or Marius Reboul's White Jasmine for the company, L. Givaudan, would go back into Rigaud's *Un Air Embaumé* in 1912.

Whilst the fashion was more for violet fragrances, Jacques Guerlain also offered *Jasmiralda* (1915) as one of his many perfumes. Parfums de Rosine, of the couturier Paul Poiret, offered *Jasmin de Rosine* (1918) and *Coup de Foudre*, the first jasmine and aldehyde perfume created by Henri Almeiras, Rosine's perfumer. Mury had their *Jasmin* (1917), and Mistinguett put Gellé Brothers' *Jasmin Suprême* on special offer.

Despite a sizeable use of dyes, infusions and washes of perfumed fats which were closer to the natural odour for the perfumers of the Belle Epoque (Edwardian era), trade in these slowly disappeared after the First World War due to the volumes which had to be used and above all the taxes affecting the transport of alcohol. Concentrates of perfumed fats also disappeared, to be replaced by absolute essences, except for the jasmine pomade, where only the flower surpluses were processed with petroleum ether to obtain the absolute. This, too, came to an end at the end of the 1930s.

To Ernest Beaux, the future creator of Chanel's No. 5, *"all perfumes had a little common, heavy note to which we were accustomed. They were not very stable and spoiled after some time, despite the processing and 'glaçages' (refrigeration)* they underwent".*

France emerged from the popular euphoria after the war impoverished and in debt. To part of the population, mundane life was hectic, fashion was for the exotic and eccentricity was acceptable to the point where the era is known as *Les Années Folles* (the years of madness).

The industrialists of Grasse, entrepreneurs and great travellers, got their supplies from abroad or from their North African properties to produce the essential oils and concretes needed for their business. Exotic essential oils such as ylang ylang, called "the poor man's jasmine", were used by the perfumers of the time. This did not prevent Ernest Beaux using more than 10 % of them in creating Chanel's No. 5

* "Glaçage": operation consisting of refrigerating an alcoholic solution at approximately 0 degrees so as to facilitate the precipitation of the least soluble substances (vegetable waxes) and obtain, after filtration, the clearest and most stable product possible.

in 1921, which he designated "my priceless Manillan ylang" and to which he was as devoted as he was to the jasmine and the rose. At Lanvin, perfumes created by Madame Zed, a perfumer of Russian origin, just like Ernest Beaux who composed *My Sin*, had been sold for some years. Success came in 1927 with *Arpège*, André Fraysse's first creation, a harmony of jasmine, rose and amber, presented in a black ball immortalised by Paul Iribe's engraving, then with the perfume *Scandal* in 1932, a very bold harmony of jasmine, leather and vetiver.

The use of jasmine was greatest this century during the 'years of madness'. Six to seven tonnes of nothing but the Grasse absolute, because jasmine no longer came just from the aromatic town, but also from Italy and Egypt, with their olfactive tones signifying their origins. To Ernest Beaux, a jasmine absolute was of a very fine quality "if it is characterised by a fleeting but clear note of blackcurrant from the Grasse soil".

At the beginning of the 1920s, fewer than ten or so constituents were identified in jasmine, these being benzyl acetate, benzyl alcohol, benzyl benzoate, linalol, indole, methyl anthranilate, also found in L. Givaudan's composition of *Jasmin Blanc*, just like linalyl acetate, the presence of which was denied a few years after.

In 1923, Descollonges discovered Flosal or alpha amyl cinnamic aldehyde, which did not exist in the structure of jasmine, but the odour of which reproduces the Grasse tonal quality of the jasmine perfumed fat (pommade). Since Descollonges preferred selling fragrant compositions, Flosal was used belatedly and initially for the tuberose and lily of the valley floral harmonies, the scents of the 1940s.

Georges Mallet at Firmenich isolated Jasmolactone from the processing residues of the jasmine perfumed fat (pommade), and the Ruzicka team started production in 1933 of the Jasmone, discovered by Treff and Werner. Inspired by Chuit's Jasminia, the perfumer Maurice Chevron created Jasmin 231, a harmony of benzyl acetate and substances not found in jasmine, such as Cyclosia or hydroxycitronel-

Eau de toilette label
Paper
5.3 cm × 6 cm
Late 19th century
M.I.P. Collection

lal, phenylethilic alcohol and paracresol. This jasmine with the tonal qualities of narcissi rapidly became successful. There were many imitations of it and it is still present today. It was used in Dana's perfume *Canoë*, a Jean Carles creation in 1935 on a jasmine and lavender harmony, and in Patou's *Joy*, the couturier Jean Patou's final request of his perfumer Henri Almeiras in the search for a perfume created solely from jasmine and rose. This perfume, the most expensive in the world, was a pause in the years between the two wars, the years of an elitist society.

At the beginning of the 1950s, holidays became the sole religion for the French. The refrigerator and the television were essential in every home. Perfume became a consumer product. Every young couturier wanted to put his name to a perfume. To meet the needs of an increasingly popularised perfume industry, jasmine from Morocco was added to the jasmine from Italy and Egypt around 1950, followed by jasmine from India in 1970 and then China. Many bases which would assist creativity were added to the wealth of these sources.

Jasmin 231, created in the 1920s, was found in Madame Grès' *Cabochard*, a jasmine, leather, aromatic chypre created in 1959, then in Paco Rabanne's *Calandre* (1969), Revlon's *Charlie* (1973) and Giorgio's *Giorgio* (1981).

The "Jasmine Flower" base with the tonal quality of the orange flower, created by Hubert Fraysse in 1947 at Synarome, was used for *Madame Rochas* (1960) and Hermès' *Calèche* (1961).

The Jasmin 62 Floraline, created in 1962 at Charabot, a jasmine base with scents of the jasmine flower and raspberry jam, was used for Van Cleef & Arpels' perfume *First* (1976), with jasmine, narcissus and blackcurrant scents which would have seduced E. Beaux, who loved to smell this note in his jasmine.

Jasmin 2000 from Oril had the same tonal quality for Yves Saint-Laurent's *Opium* (1977) and for Oscar de la Renta (1977).

Following research work by Demole on the composition of the jasmine absolute, Firmenich finalised methyl dihydrojasmonate or Hédione in 1962, the name of which originates from "hediosmia", an imaginary flower of Jamaica, "with French jasmine odours", mentioned in J. K. Huismans' novel, *A Rebours*. This new substance, which aroused no great interest at the beginning of the 1960s, was used for the first time in 1966 by Edmond Roudnitska to create Christian Dior's *Eau Sauvage*. Methyl dihydrojasmonate was not the sum total of *Eau Sauvage*, but *Eau Sauvage* did make methyl dihydrojasmonate one of the most widely sold synthetic substances in the world. Methyl dihydrojasmonate was used to excess in creating Van Cleef & Arpels' *Miss Arpels* (1994).

In 1972, Christian Dior launched *Diorella*. In creating a simple, intense, modulated, unexpected olfactive form on the jasmine theme, Edmond Roudnitska favoured singing to noise and rejected the deaf, rowdy notes of musk, balsams and vanilla. This theme expressed all the brilliance of the composer; his intuition preceded the revelations of the analysis of the "head space", because the perfume breathes, has an occasionally provocative rhythm due to its strange notes, arousing the desire to smell and smell again. Edmond Roudnitska reaffirmed that perfume is not just an association of fragrant materials, but a composition of the spirit.

Since the discovery of benzyl acetate in the composition of the distillate of the jasmine pommade, analytical techniques have profoundly changed the way in which we smell and create jasmine. *Eau de Givenchy*, created in 1980 by Daniel Hoffman, was the first perfume to contain the "head space" of the jasmine, a base resulting from a new technique at the end of the 1970s. Today, biochemists travel the world to capture the aura of the most fragile, most remote, and the rarest or

Publicity photograph for Madame Rochas perfumery products From "House and Garden", December, 1960 M.I.P. Collection

Jolie Madame...

Balmain

► Right:
Perfume bottle of Jolie Madame
by Balmain
Clear glass and plastics, 1953
M.I.P. Collection

▲ Facing page:
Advertisement for
Jolie Madame by Balmain
From "Jours de France", 1977
M.I.P. Collection

*Perfume bottle of Cabochard
by Grès
Clear glass and plastics, 1959
M.I.P. Collection*

most infrequently grown flowers. In so doing, they recall the spirit of the great botanical explorers of the 17th century, who brought back to Europe the first plants of the countries of the Levant, which were not put on public display until the 18th century in the botanical and zoological gardens.

Whilst the "head space" technique demonstrated the difference between the living plant and the picked flowers in the olfactive composition of jasmine flowers:

CONSTITUENTS	LIVING FLOWERS	PICKED FLOWERS
Benzyl acetate	60 %	40 %
Linalol	3 %	30 %
Indole	11 %	2 %
Cis-jasmone	3 %	traces

and therefore the circadian character of the odour, this form of analysis also offers an interesting olfactive classification based on four archetypes of flower odours found in nature:

– White flowers with jasmines, honeysuckle, tuberose and gardenia. The heart of their composition is basically made up of linalol and hexenol esters. Their differences are expressed by methyl anthranylate, indole, benzyl acetate and jasmones.

– Pink flowers with roses, lily of the valley and cyclamen basically structured around citronellol, geraniol, phenylethilic alcohol and its compounds as well as damascenones.

– Yellow flowers or ionone flowers such as freesia, boronia and osmanthus basically structured around ionones.

– Spicy flowers such as carnations and the star jasmine (*trachelosperum jasminoides*), basically made up of eugenol and isoeugenol.

Today this gentle technology offers perfume creators "head spaces" in the form of bases with such names as "vitessences" for Haarmann & Reimer, several types of jasmine such as Arabic jasmine or polyanthum jasmine, full jasmine or sambac jasmine.

If you were to smell the perfumes from the beginning of this century, you might through memory or nostalgia be amazed or disappointed by their form, but you would never smell them as they were then perceived. For despite all our knowledge

Jasmine perfume
label by Molinard
Paper
2.6 cm × 2.4 cm
c. 1900 M.I.P. Collection

of the techniques used and our efforts to understand, perfume, just like songs, films, fashion, newspapers, and cookery recipes of only 20 years ago, encompasses meanings, allusions to society's customs of the time which we will never regain. Our sight, hearing, sense of taste and smell has also changed. Fashions are brighter, sounds harsher, tastes sweeter and perfume... well, that's for you to decide !

Jean-Claude ELLENA,
Creator of Perfumes, Haarmann & Reimer

Chance, or rather choice in life has brought me back in recent times to the places where almost all the perfumes of Europe are born or made....

The farmer's work is governed by a kind of uniquely floral timetable, where two adorable queens rule in May and July, the Rose and the Jasmine. Around the year's two sovereigns, one the colour of the dawn, the other clothed in white stars, countless, swift violets, tumultuous daffodils, simple narcissi pass by from January to December, and eyes are filled with wonder at the enormous mimosas...

Maurice MAETERLINCK : L'intelligence des fleurs, 1907.

THE WHITE ROBE OF BEIRUT

Jasmine, *il-yâsmîn*, is the supreme bush growing in gardens and pots on the balconies of the houses of Beirut. It is often accompanied by a henna tree, a frangipani and a multitude of little pots of *fil* (Arabian jasmine), basil, mint and marjoram. These scents perfume the town with their warm, yet fresh breath. The perfumed entrances to the houses welcome all those who pass through them. The stems of the jasmine harden only gradually, so that tunnels and archways can be shaped from them, and balustrades and hedges embellished with them. Sometimes the jasmine is left to climb a wall or fill out. Hospitality, in other words, the duty of honouring the guest, is strengthened by the fragrant welcome of a jasmine in all its splendour and radiance at the threshold of houses.

In Beirut as in other Mediterranean towns, the terraces and balconies are the link with the outside world. Overhanging the street, they are the focal point for conversations from balcony to balcony or balcony to street. They make it easier to buy fruit and vegetables from itinerant traders. The public domain thus penetrates the private dwelling. They are also the places where people prefer to socialise, close to the jasmine, in an area which is distinctive due to its smell, sight and often its touch. Morning, afternoon and even evening visits revolve round a coffee, hookah or a meal. Before leaving, the guests are given a few flowers in a handkerchief. This gift of a sweet-smelling souvenir of the visit is to help them on their way. These visits establish or renew bonds of friendship. Social integration therefore means in part being fragrantly welcomed into the host family, encouraging social harmony. The gratifying experience is therefore the mechanism by which social bonds are regulated.

At night, the scent of the jasmine is even more pronounced because, when all the odours of the town subside, its perfume invades, *tifi'*. In some houses with a courtyard, where there is a pool, flowers are arranged both for their scent and their lovely appearance *(manzar helou)*. Beirut's floral terraces convey the importance of the "green stem" (*'oro' akhdar*), which brings good luck and calms the spirits. It introduces the natural element into cultural organisation.

Certain olfactory images hark back to childhood. Jasmine in particular is one of these. Children wait impatiently for it to flower, worry if it does not start to bud and count the months until it comes into flower. They say, for example: "it's one month since it started" etc.. One children's game consists of threading flowers with pine needles or making necklaces and bracelets to give to their mothers.

To say hello, one generally says: *sabâh il-khair* (good morning), one replies either *sabâh il-khair* or *sabâh il-nour* (morning of light). To close friends one may reply, *sabâh il-fil wal yasmîn* (the morning of the Arabian jasmine and the jasmine), in other words, "I wish you a fragrant morning full of goodness like the jasmine". The sight of it makes one happy, its generous odour cheers, delights, communicates good spirits and hope: "smell the scent of this jasmine

and forget your troubles", (*shîl il-ham*) is what is said to someone who is anxious.

Jasmine is grown for oneself, one's family, to make one's landscape different. It is not planted for farming. Being a fundamentally family flower, no jasmine distillation traditions have developed. In the past, the flower was distilled to obtain its essential oil by collecting the parents', neighbours' and friends' flowers.

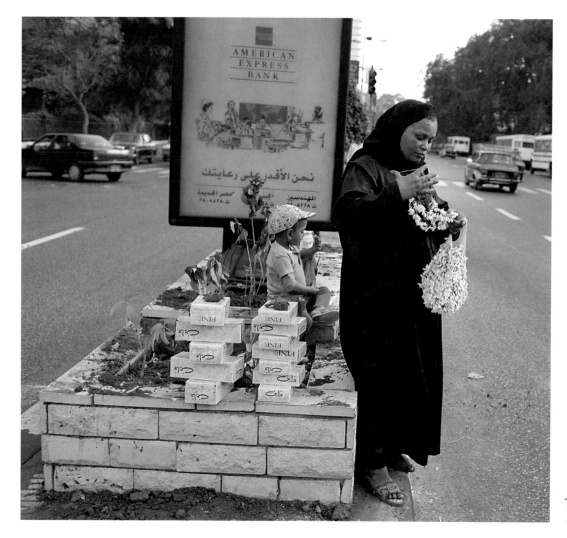

*Woman selling
jasmine necklaces
Egypt, summer, 1995
M.I.P. Archives*

Some women thread a few jasmine flowers, group them in little knots and pin them in front of their ears. Others place a few flowers on their breast simply for their scent. To make themselves smell nice, they may also use a tuberose, a few frangipani flowers or a gardenia.

Jasmine is compared to a woman, or a woman's hair. Generous, abundant, good, it is a female symbol. It is the only one of the flowering plants, the name of which may be given to women. Strongly associated with women, the flower is often given by men to their beloved as necklaces, bracelets, or simply a branch of flowers. But it is also given to mothers, nieces, sisters, aunts and any woman to whom one wishes to show affection or affinity.

Jasmine is also a private, intimate scent. Brought in from the outside, the flowers are delicately placed in a saucer filled with water to perfume the insides of the houses for a few hours, particularly the reception rooms and bedrooms. The scent of the jasmine, it is said, is as penetrating as the sun's rays and therefore has therapeutic virtues. Some women prepare plates of flowers to put next to the children when they are sleeping "so that they sleep better and have sweet dreams". Dried flowers can also be used in camomile, lime-blossom, verbena, cherry stalk, corn tuft, rosebud and hibiscus flower teas to lightly perfume them.

Those who have large jasmine bushes in their gardens benefit from making necklaces and bracelets to sell. Others give the flowers to poor families whose members make necklaces. Taxi and "service" (kind of commonly-owned taxi) drivers are particularly fond of them. In decorating their car mascot, they perfume the small area in which they travel. The scent, fleeting but profound, pervades throughout the journey.

The taxi or "service" driver decorates *shakkil* his car, which he calls his fiancée, with photos and verses of poems. The steering wheel and seat are trimmed with a sheep skin, also regarded as a lucky charm. He protects his car, his main means of living, from the evil eye with necklaces of blue pearls, pictures of eyes, a horseshoe or a slipper, or again with threatening sayings of the evil eye such as "the eye of the envious shall not live" (*ain il-hasoud la tasoud*). He decorates his car, which he talks about as if it were a woman, with jasmine necklaces which exhale a perfume with the passing hours, a perfume which overcomes the odours in the car. The car, with all its curves, is the companion, the mother, she who surrounds and shelters her driver. He dresses it so as to be proud of it. He shows it off because it reflects his power. Apart from the fact that it is his work tool, it gives him gratifying emotional, sensual feelings.

To make the necklaces, the buds which are white or very pale pink and slightly puffed out, are carefully detached. The flower is closed but mature, ready to blossom in the coming hours. The pink firm buds are left for the following day. Flowers which have already blossomed are kept on the plant as they will fall off by themselves. By taking only the buds and not the flowers, the life of the jasmine's scent is extended. To thread them, the stem at the base of the buds is pricked to limit the risks of the stem being torn by the thread. The buds are then separated from each other so that the flowers do not fade quickly.

The threaded necklace is folded then placed in moist paper. It is kept in a cool place for several hours until the time it is sold. As they come into contact with the air, the flowers open out. The necklaces are always suspended out of respect for the flower which is known to be extremely fragile. They are sold on a wooden stand at cross-roads where those selling them take advantage of the traffic. They have also been sold in front of cinemas, on beaches, shopping streets, along the coast and at the entrance to the airport. Thus, travellers take the scent of Beirut away with them, for the duration of their journey. The women and children gather, thread and sell the jasmine. The men, too, may also sell the precious necklaces.

Brides wear a collar or crown of jasmine as a symbol of life and happiness. Some wedding dresses are stitched with motifs of jasmine petals. When newly-weds pass by, a few flowers are strewn over them. They are offered and paraded at religious festivals. Both Muslims and Christians receive jasmine necklaces for their respec-

tive festivals as a token of warmth and esteem. These gifts are part of more general exchanges between the two communities.

Necklaces, a symbol of purity, deck the statues of the Virgin and the icons in churches. In Christian families, a *madbah*, a private altar decorated with jasmine, candles and the images of saints are prepared at certain festivals, such as that of the Holy Sacrament. Necklaces are hung on the screens of the saints, Muslim and Christian, when a vow is taken, and also around photos of the dead in order to recreate the living spirit. The souvenir and the memory of someone close is therefore kept fragrant.

To safeguard its virtues of purity and life, women who are menstruating do not go near the plant because menstrual blood has a destructive power. In this case, it would dry out the plant. Their presence is not desirable because they constitute an unstable presence which would weaken the jasmine's health.

Jasmine flowers earlier on the coast than in the hills. When it starts to flower, jasmine heralds the spring. It is the *mawsam il-yâsmîn*, an emotional reference. Its abundant flowers spread out over the summer. Each day it produces a few more. To begin with, there are not many flowers because the foliage is still not very thick, the plant having been heavily pruned. Later, when the foliage is of a good volume, the flowers become very numerous, and the scent persists. Jasmine flowers from June until the end of the summer, and often well into October. It may even flower slightly up to five hundred metres in January and February. It grows in the mountains, but with difficulty above a thousand metres.

Gardenia and frangipani (*fitné, de fatina*: to seduce) also hold an important position in Beirut's flowery domestic landscape, but to a lesser degree. Compared with gardenia, which is considered difficult, the season of which only lasts three or four weeks around May, jasmine is easily grown and its flowering season is considerably longer. It starts when gardenia's finishes. Aromatic continuity is therefore ensured. In contrast to the gardenia, the perfume of which lasts several days, even if the flower goes a little brown, the perfume of the jasmine lasts only a few hours. It is fleeting, highly ephemeral the "daughter of its time". Its whiteness quickly fades and its perfume with it. Its perfume reflects its whiteness; as the whiteness fades, the perfume is no longer given off. Its colour and scent unite and form an harmonious entity. Gardenia, however, continues to give off its scent well after its whiteness fades. The nature of the scent of the jasmine (*tikhmar*, ferments) changes even more quickly when the flower is worn next to the skin or comes into contact with clothes. Its whiteness is dazzling, but delicate and fine. Its scent is intense, but fleeting. You never become accustomed to its perfume, and so are constantly renewing it. Its long season fortunately allows this.

So that it "bears" (*yihmil*, same terms used for pregnancy) as many flowers as possible, the stems of the jasmine, which have grown very thick during the summer, are cut. Whilst it does not need particularly rich earth, jasmine is all the more prolific if the stems are cut at the right time, i.e. in March or April. All the flowers' work is generally over by February. Early stripping of the jasmine, however, may disturb its flowering cycle and an exception is therefore made. It can also be fertilised when the soil is turned.

If its base is bare, the jasmine is watered frequently in the evening after sunset. Spraying is less frequent when the base is protected by leaves. What is more, it is easily attacked by greenfly and tiny worms which feed on the leaves and buds.

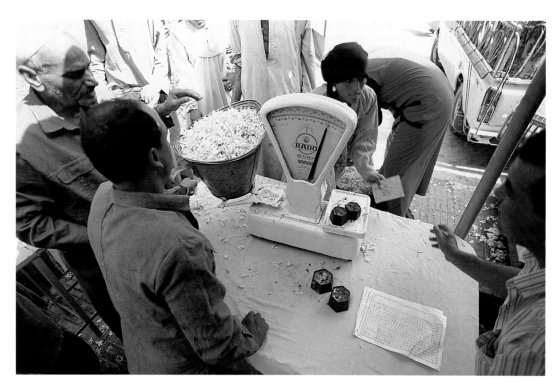

Weighing the flowers
Egypt, summer, 1995
M.I.P. Archives

They are then sprayed with insecticide. In winter, the shrub stays green and thick but its leaves turn a dark green.

To produce a new plant, the method often used is propagation by cuttings, *shatli*. When, at the end of spring, the new green, tender branches push through, one end is sunk into the earth or a pot, leaving the other end of the branch in the open air so that it continues to grow. Some time later, the sunken branch produces roots. The mother stem can then be cut. The branch is watered frequently so that it takes well.

Goddess of the Beirut flowers, the jasmine flower celebrates the spring and the arrival of warm weather. It is the flowery emblem of hospitality. As it perfumes the social life jasmine, the attribute of intimacy and affection, does not convey an exclusively sexual image. It is symbol of the feminine with a childlike bloom. Its olfactory generosity is expressed both in its private and public use. As it spreads, grows and improves as the days go by, jasmine symbolises the popular, gentle way of life. Its flower is the seat of a personal and social, internal and external sensitivity.

Aïda KANAFANI-ZAHAR,
CNRS, Laboratoire d'Ethnologie Méditerranéenne et Comparative
(Laboratory of Mediterranean Comparative Ethnology)

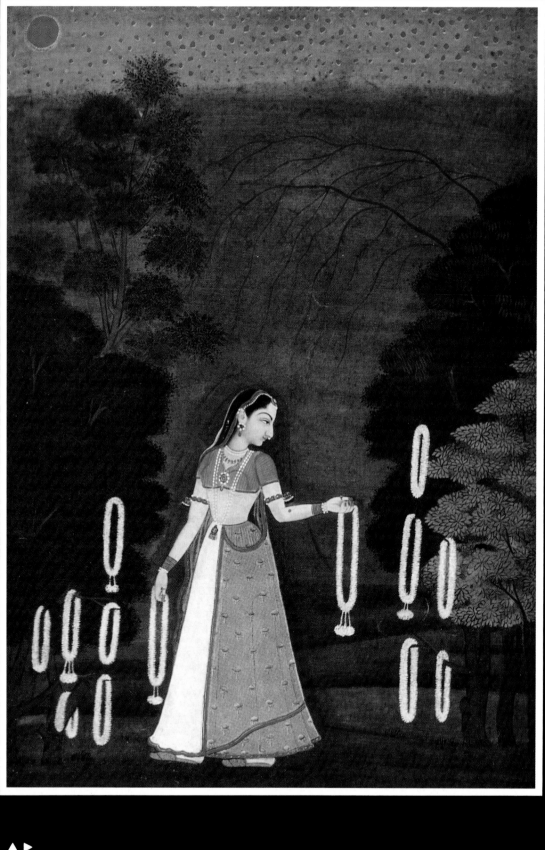

Young Gujerati woman, Moghul art, early 18th century,
in Indian Miniatures by Mario Bussagli, Hamlyn Publishing Group, Feltham, 1969

AMIDST THE INDIAN JASMINES

The Indian flower par excellence, the noble, majestic, almost divine flower, from which the god Brahma, the Creator, came, the flower which evokes the face of the beloved or the sacred feet of the guru, emerging immaculate from the mud of the swamps, is the lotus.

Everything that is beautiful, pure and venerable is compared with the lotus. We could not list all the comparisons allowed by its corolla in full bloom, its closed bud swollen like a maiden's bosom, its petal wide like the eyes of a beautiful woman, its stem straight like the world's axis.

But there can be no mistaking it. Where the poverty of our language means that we are only able to provide alternative names for the lotus, of nymphea, Nile lily, water lily, the rich diversity of the Sanskrit vocabulary offers a profusion of words : *padma, puskara, kamala, rajiva, utpala, kumuda, aravinda*, pink lotus, white lotus, blue lotus, day lotus, night lotus, *jalaja, udaja, ambuja, niraja, pankaja, saroja, ambhoruh*, and so on !

Whims of vocabulary or indeed varied species with which royal pools are adorned, as are lakes lost in the jungle and village ponds where man and buffalo bathe, where shouting children play and where the majestic, placid elephant tirelessly sprays himself.

Nevertheless, the lotus lacks something. In this country of perfumes which are so diverse and sometimes so powerful, the lotus only has a very unobtrusive scent.

There are other more modest flowers which perfume the breeze throughout the seasons, the *bakula* (Mimusops Elengi) which blossoms, it is said, when sprayed with the nectar from the mouth of the beloved, the *madhavi* (Gaertnera Race-mosa), the *patala* (Bigonia Suaveolens), the *ketaki* (Pandanus), the *kadamba* (Nauclea), the *sephalika* (Vitex Negundo), the *suvaha* (Nyctanthus Arbor Tristis), and perhaps above all the majestic *arjuna* (Terminlia Arjuna), and then in spring in whole bunches, the *campaka* (Michelia Campaka) and the clusters of mango tree flowers.

Among such a wealth of flowers, what place is given to the humble jasmine? When we dip into a few major works of Sanskrit literature, we are surprised to note that allusion is seldom made to jasmine.

Even Jayadeva, in the admirable **Gitagovinda**, which owes part of its charm to so many botanical references, only mentions jasmine by name three times, and the famous **Nuage messager** (Messenger Cloud) of Kalisada twice!

The dictionaries, however, are familiar with several varieties of jasmine: the *malati* in particular, which is the *Jasminum Grandiflorum*, the modern *cameli* or *cambeli*; the *Zambac* jasmine, called *mallika* and also *motiya* in Sanskrit and in several modern languages because of its translucent shine reminiscent of that of the black pearl (*moti*); the *Jasminum Pubescens*, *kunda* in Sanskrit (*kund* in Hindi).

But in practice, what confusion! Real botanical skill cannot be demanded of florists or of poets... even less again then of translators who convey the most varied flowers by the word "jasmine".

It is the jasmine which enhances the jet-black opulence of the coils or plaits of

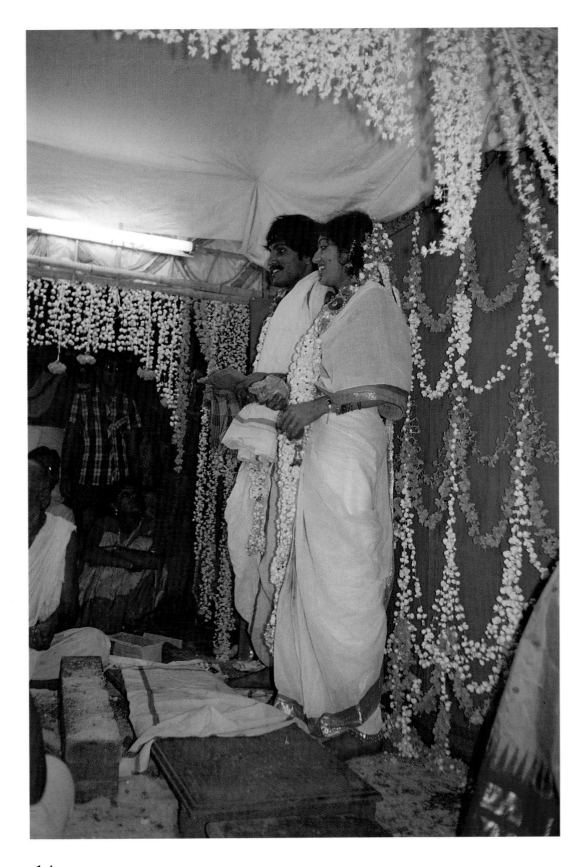

◄ ▲
*Facing page and above: Brahmin marriage ceremony
in Vijayawada, Andra Pradesh Andra Pradesh, India, 1982 Photo: E. Naudou*

hair with its whiteness and perfume. The **Cycle of the Seasons (Rtusamhara)**, a poem attributed to Kalisada (5th century) already tells us that in autumn
"The women fill their magnificent, thick, black, curly hair
with new jasmine ; on their ears pierced with gold earrings, they
hang lotus flowers in varying shades of blue."
(Trad. R. H. ASSIER de Pompignan, III, 19)

This finery has a dual role since it dispenses with the need for perfume. A lyrical poet, almost contemporary with Kalisada, writes :
"Is there anyone whose joy is not increased when the rainy season
comes and sets love alight, love adorned as a girl, heavy with the perfumes
of the flowering Jasmines and laden with clouds or swollen, heavy breasts ?"
(**The Erotic, Moral and Religious Stanzas of
Bhartrihari**, trad. P. Regnaud, st. 41)

It is these jasmine varieties which are being used again today to build the fragile canopy (in screens of garlands) under which the betrothed, then man and wife, sit during the wedding ceremony, when they have exchanged the nuptial garlands and encircled the sacred flame.
Jasmine is one of the many flowers covering the body which is carried to the funeral pyre.
The teeth of beautiful women are also compared to the dazzling jasmine. The image is a frequent, almost banal one, like Jayadeva's **Gitagovinda, book X.**
In Kalisada's **Cycle of the Seasons,** it is conversely the flowers which evoke the teeth, thus initiating personalization of the Spring :
"The spring triumphs through the brilliance of the jasmine flower
over the smile of the beautiful women revealing the brilliance of their teeth."
(Ibid. VI, 29)

Here She comes, laden with flowers :
"The honey of her lips resembles the blue asoka, her host of teeth is a
crown of jasmine, her face a lotus in full bloom, her breath heavy with the
perfume of mango trees."
(Ibid. VI, 34)

It was probably Vidyapati, however, the pious, sensual poet singing of the passions of Krsna and Radha, who gave fullest expression to the image, since he contented himself with evoking the smile without mentioning the teeth :
"Spring appears when the white jasmine (*kunda*) flowers in majestic smiles."
(**Love Songs of Vidyapati**,
trad. De Deben Bhattacarya, song 47)

Jasmine *Grandiflorum*, however, the *Malati*, is also more than that, even if it has been modestly concealing this role for a long time until a mystical mediaeval poet consecrated it. The *malati* is the symbol of the beloved.
It was certainly not by chance that Bhavabhuti, an 18th century playwright, linked the names of the lovers Malati and Madhava, "jasmine" and "spring", in the title of one of his works (**Malatimadhava**).
Madhava, however, is also one of Krsna's names !
Much later, at the end of the 14th century, Vidyapati compares the young god intoxicated with love to a bee in a poem written in the lovely maithili language :

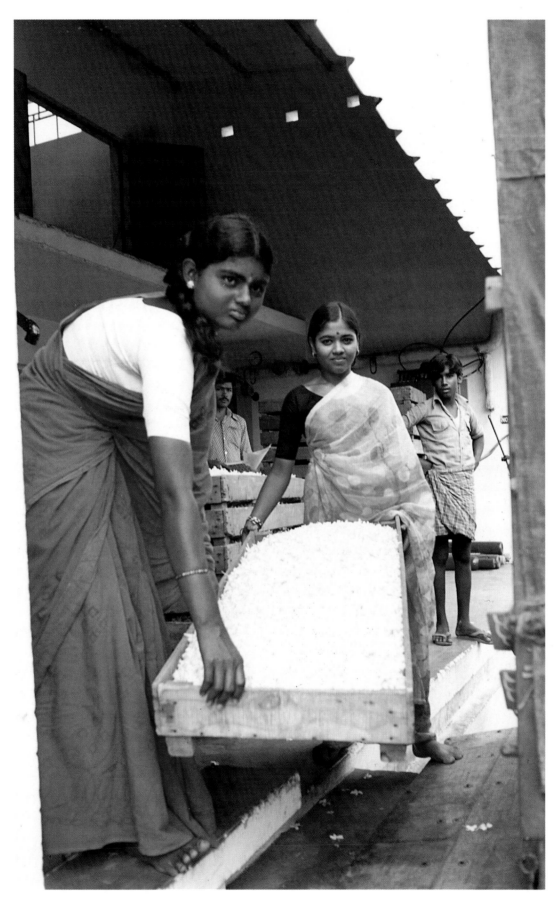

*Jasmine arriving
at the factory
India, c. 1990
Private collection*

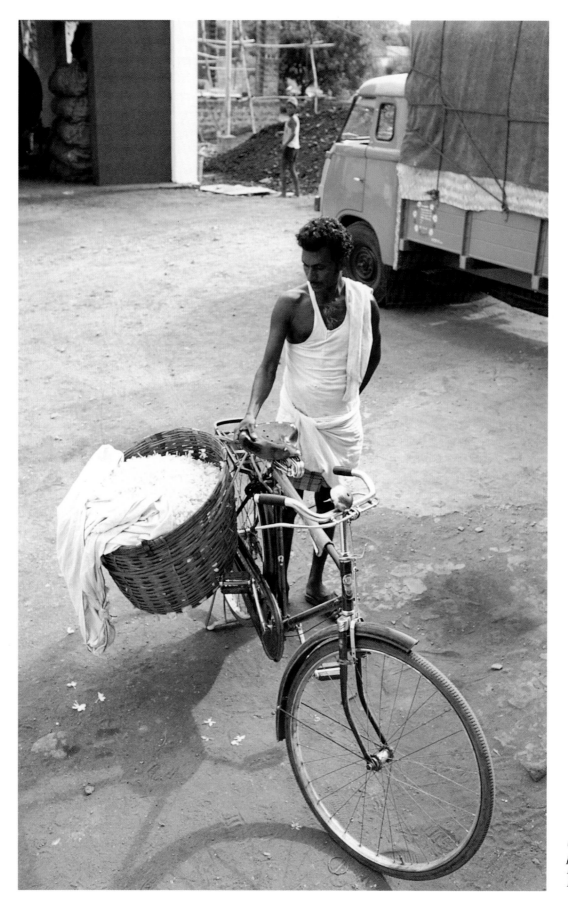

Outside the
perfume factory
India, c. 1990
Private collection

"Oh Malati, my sensuous white flower...
Unceasingly and unceasingly
He longs to drink from your cup...
Honey is his life."

"Oh Malati,
My ocean of honey,
Have you no shame in keeping this treasure for yourself?
Whom can you blame for his death.
If you yourself are his murderer?"

(Song 20)

It is true that there are many other flowers, *jetaki* and *ketaki*, and so many others with delicious honey. But even while dreaming, the divine lover turns away from them!

"Oh Malati,
My flower of perfumed honey,
Your lover is here.
Let the bee relish
His fill of sensual delight."

(Song 21)

The appeal will be heard:

"In a deep embrace
He entwines the stem of her body
With his arms like branches.
Throughout the night
Krsna makes love to her
As a bee lingers
On the sensuous Malati.
The forest opens out
Flowering with white kunda,
But the bee is captivated
By Malati and her honey."

(Song 48)

The Indian earth abounds with perfumes and flowers, but who can forget the perfume of the jasmine?

"Ah! These Jasmines! These white Jasmines! I think I still remember
the first day I filled my arms with these Jasmines, these white Jasmines!
I loved the sun's light, the sky and the green earth.
I heard the silvery river tinkling in the midnight darkness.

BIBLIOGRAPHY

DICTIONARIES

M. Monier-Williams, *Sanskrit-English Dictionary*, New Edition, Oxford, 1956.

John T. Platts, *A Dictionary of Urdu, Classical Hind and English*, Oxford University Press, 1968.

BOTANY

Vishnu Swarap, *Garden Flowers*, National Book Trust, Delhi.

M.S. Randhawa, *Flowering Trees*, National Book Trust, Delhi, 1965.

LITERATURE

The Complete Works of Kalidasa, edited with an introduction by V.P. Joshi, E.J. Brill, Leiden, 1976.

Bhavabhuti, *Malatumadhava*, Sanskrit play, translated into old French by G. Strehly, Paris 1885).

Jayadeva, *Gilagovinda*, Sanskrit lyrical poem, translated into french by G. Courtillier, Paris 1904 and J. Varenne, Paris 1991).

Bhartrhari, *Sringarasataka*, lyrical love poem, translated by P. Regnaud, Paris, 1875).

Vidyapati, *Love Songs*, translated by Deben Bhattacharya, Motilal Banarsidass, Delhi, 1963.

Rabindranath Tagore, *Le Jardinier d'amour, La Jeune Lune*, Gallimard, Paris, 1980.

Marriage ceremony in Andra Pradesh Andra Pradesh, India, 1982 Photo: E. Naudou

The autumn and the sunsets came to meet me as
a path turned into solitude, as a fiancée lifts
her veil to receive her beloved.
My memory, however, is still fragrant with the scent of those first
white Jasmines I held in my infant hands."

(Rabindranath Tagore, **The Gardener of Love** trad.
By H. Mirabaud-Thoren)

Elisabeth and Jean NAUDOU,
University of Provence

▲ *Funeral procession prior to cremation Kunur, Tamil Naidoo, India*

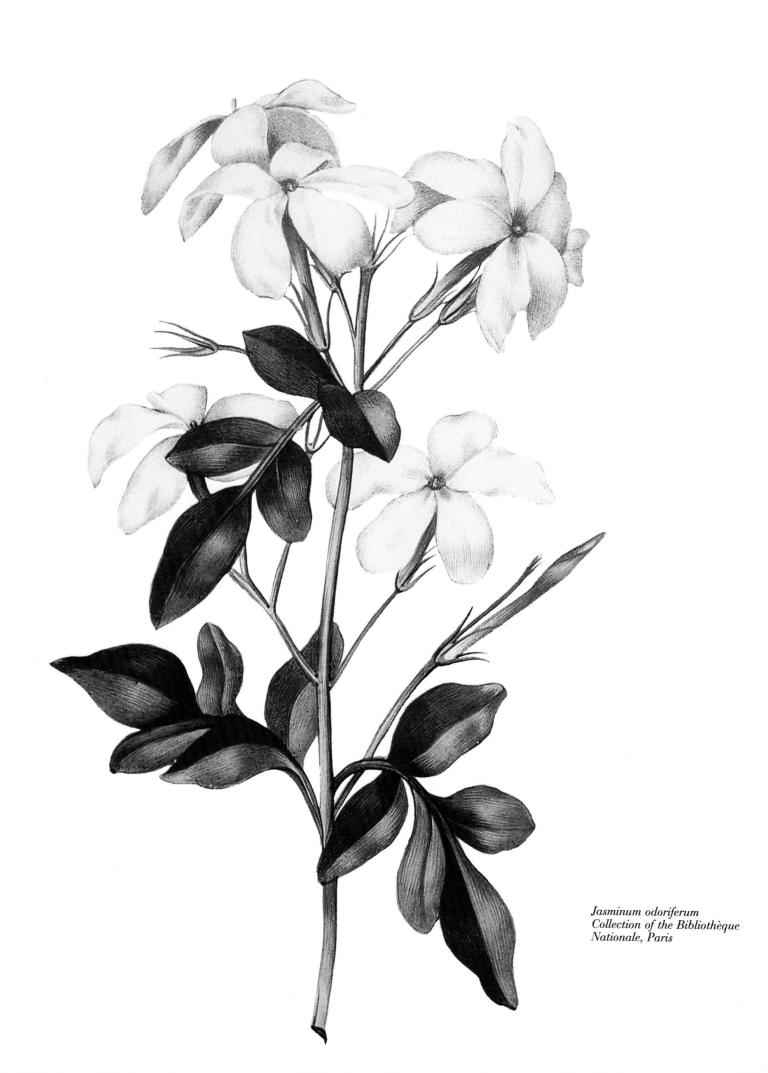

Jasminum odoriferum
Collection of the Bibliothèque
Nationale, Paris

SOME JASMINE PERFUMES...

*Jasmine perfume
label by Molinard
Paper
6.5 cm × 6 cm
c. 1950
M.I.P. Collection*

1860
MOLINARD, *Jasmin*

1885
GUERLAIN, *Jasmin du Siam*

1894
ED. PINAUD, *Jasmin de France*

1900
CARLOVA, *Jasmin Fascinato*

1902
LUNDBORG, *Golden Jasmine*

1908
CROWN PERFUMERY, *Jazmin del Pais*

1909
CARTIER, *Jasmin*
GEORG DRALLE, *Jasmin*

1910
GRENOVIL, *Jasmin Blanc*

1911
CARON, *Jasmin*
GODET, *Trésor de Jasmin*

1913
GODET, *Jasmin Fleuri*
WOLFF & SOHN, *Jasmin and Narcissus*

1914
ORIZA L. LEGRAND, *Jasmin d'Asie*

1915
GUERLAIN, *Jasmiralda*
PARFUMS DE ROSINE (Paul Poiret), *Jasmin de la Riviera*

1917
GELLE FRERES, *Le Jasmin Suprême*
MURY, *Le Jasmin*

1918
PARFUMS DE ROSINE (Paul Poiret), *Le Jasmin de Rosine*

1919
ARYS, *Jasmin*
COTY, *Jasmin de Corse*
FONTANIS, *Jasmin*

1920
ARLY, *Jasmin*
BABANI, *Jasmin de Corée* (around 1920)
BERNARD ET ROGER, *Jasmin*
FIVRET, *Jasmin*
GELLE Frères, *Jasmin Suprême*
GUELDY, *Le Jasmin*
HOUPIGANT, *Jasmin*
LYDES, *Jasmin*

1921
BOURDAY, *Jasmin Rêvant*
BOURJOIS, *Vrai Jasmin Rêvé*
GIRAUD Joseph & Fils, *Fleur de Jasmin*
MURAOUR, *Jasmin*

1922
AMERICAN TOILET GOODS, *Cape Jasmine*
ELISABETH ARDEN, *Arden Jasmin*
GUERLAIN, *Jasmin de Siam*
LA VALLIERE, *Grand Duke Jasmine*
LENTHERIC Guillaume, *Jasmine Orchidée*
LUYNA, *Le Jasmin*
MIRO-DENA, *Jasmin de Paris*
ED. PINAUD, *Jasmin Roy*
SAUZE, *Floraison de Jasmin*
VOLNAY, *Jasmin du Cap*

1923
CIRO, *Doux Jasmin*
D'HERAUD, *Jasmin*

Above:
Perfume bottle of Jasmin
de Corée by Babani
Clear glass, c. 1920
M.I.P. Collection

◄ *Facing page:*
Perfume bottle of Diorissimo
by Christian Dior
Baccarat crystal
and yellow metal,
1956 M.I.P. Collection

D'ORSAY, *Jasmin*
GODET, *Jasmin Fleuri*
LUYNA, *Le jasmin*
PIVER, *Jasmin*
RAMSES, *Jasmin d'Egypte*
VIOLET, *Jasmin*

1924
BOUTON (George W. Button Co.), *Black Jasmine*
GABILLA, *Jasmin*
GUERLAIN, *Jasmin*
FRACY, *Jasmin Passionata*
ISABEY, *Le jasmin d'Ysabey* (around 1924-1928)
JASPY, *Jasmin*
LE BLUME, *Jasmin*
PELISSIER ARAGON, *Jasmin*
V. VIVAUDOU Inc., *Jasmin noir*

1925
BONWITT TELLER Inc., *Fleur de Jasmin*

1926
BALDWIN PERFUMERY, *Doux Jasmin*
CARTIER (Dermay Inc.), *Jasmin*
DUVINE, *Jasmine*
GELLE Frères, *Jasmin Suprême*
HOUBIGANT, *Jasmin*
SCHIMMEL, *Jasmilan*
VION, *Jasmin*

1927
HENRI BENDEL Inc., *Mon Jasmin*
SILKA, *Jasmin*

1928
NESTLY, *Jasmin*

1929
FRANK C. REILLY, *Jasmin*
GUIMET, *Jasmin*
HENRI BENDEL Inc., *Jasmin du Japon*
NESTLY, *Jasmin*

1930
GUERLAIN, *Jasmin* (around 1930)
LUCIEN LELONG, *Jasmin*
MARLY, *Jasmin de France*

*Above: Jasmine essence
by J. Giraud fils
Aluminium, 1921
M.I.P. Collection*

1931
BOURGET, *Jasmine*
LUCRETIA VANDERBILT, *Jasmine*

1933
BOUTON (George W. Button Co.), *Jasmin*
DE RAYMOND, *Jasmin*
DE SECHERS, *Jasmin*

1935
MIKY, *Jasmin* (around 1935)
MOLINARD, *Jasmin*
PURITAN, *Jasmine*
SAINT-DENIS, *Les Fleurs de Jasmin*

1936
WORTH, *Jasmin*

1937
LANCHERE, *Jasmin*
HOUSE OF FRAGRANCE, *Wild Jasmine*

1940
LE FLOREAL PARFUM (HARRY A. SIMON),
Jasmine de Luxe
LE GALION, *Jasmin*
LE GALION, *Jasmin de Corse*
LILI, *Wild Jasmin*

Jasmine perfume
label by Lubin
Paper
2.4 cm × 1.7 cm
c. 1920
M.I.P. Collection

1943
BRETEUIL, *Jasmin*

1945
AVON, *Wild Jasmine*
TUVACHE, *Jasmin From Egypt*

1946
HENNEVY, *Jasmy*

1948-1950
ANN HAVILAND (Haviland laboratory), *Jasmin of the Night*
JEAN GIRAUD ET FILS, *Jasmin* (around 1950)

1954
GUERLAIN, *Jasmin 54*

1957
CASWELL-MASSEY, *Red Jasmine*

1994
LAPORTE, *Jasmin*

UNDATED

BOUIS JEAN, *Jasmin*
BRINSDOR, *Jasmin*
BRUN & BARBIER, *Jasmin*
BRUNO-COURT, *Jasmin*
CHANEL, *Jasmin*
CONDE, *Jasmin*
DANS UN JARDIN, *Jasmin*
DEA, *Jasmin*
DELETTREZ, *Le Jasmin*
DRALLE, *Jasmin*
DU MAURIER, *Jasmin*
ERISMA, *Jasmin*
FLORALIA, *Jasmin*
FLORIDA, *Jasmin*
FLORIS OF LONDON, *Jasmine*
FORVIL, *Jasmin*
FRAGONARD, *Jasmin*
GALIMARD, *Jasmin*
KLYTIA, *El Jasmin*
LABOISSIERE, *Jasmine*
LA FARIGOULE, *Jasmin*
LALARDE, *Parfum jasmine*
LE JARDIN RETROUVÉ, *Jasmin*
LESOURD-PIVERT, *Jasmin*
LIF, *Jasmin*
LORENZ, *Jasmin Bleu*
LORESTE, *Jasmin*
LORIE, *Jasmine of the Southern France*

LUBIN, *Jasmin*
LUBIN, *Jasmin d'Espagne*
MAGUY, *Jasmin*
MOEHR, *Jasmin*
MOLTON-BROWN, *Jasmin*
MONT AGEL, *Jasmin*
MONT SAINT MICHEL, *Jasmin*
MURY, *Jasmin*
MYRURGIA, *Jasmin*
NISSERY, *Le Jasmin*
NORYS, *Jasmin*
OCCITANE, *Jasmin*
ORIENTAL, *Jasmin*
PASCAL, *Jasmin*
PEELE, *Jazmin de Persia*
QUAZZA, *Jasmin*
RIVAL, *Bleue Jasmin*
ROCHAMBEAU, *Jasmin*
ROCHAMBEAU, *Jasmine*
ROGER & GALLET, *Jasmin d'Espagne*
ROMEY, *Jasmin*
RUBINSTEIN, *Jasmine*
SU NOMA, *Jasmine*
SYLVA, *Jasmin du Japon*
TAO, *Jasmin*
THIEBEAUT, *Jasmin*
VARENS Luc de, *Jasmin Jaune*
VUITTON, *Jasmin*

*Jasmine perfume
label by Nissery
Paper
3.5 cm × 2.3 cm
c. 1900
M.I.P. Collection*

Right:
Jasmine Renaissance
perfume bottle
by Erizma Paper
and clear glass
Early 20th century
M.I.P. Collection

BIBLIOGRAPHY

VARIOUS, *Classification des Parfums*, Paris, Comité Français du Parfum, 1990.

VARIOUS, *Dictionnaire des Parfums*, Paris, Ed. Sermadiras, 1987-88, 9th edition.

VARIOUS, *Osmothèque, la mémoire vivante des parfums. Brochure Historique*, Versailles, 1993.

VARIOUS, *Who's Working Where Perfumes & Cosmetics*, Paris, Ed. M.A.H.D., 1994-95.

ELLENA, Jean-Claude, "Un siècle de jasmin", in *Contact*, Haarmann & Reimer, no. 62, 1995, p. 3-9.

FONTAN, Geneviève, BARNOUIN, Nathalie, *Parfums d'exception*, Paris. Ed. Milan, 1993.

JONES-NORTH, Jacquelyne Y., *Commercial Perfume Bottles*, Pennsylvania, Ed. Schiffer Publishing, 1987.

UTT, Mary Lou and Glenn, *Les flacons à parfum Lalique*, Paris, La Bibliothèque des Arts, 1991.

Right: Calèche perfume bottle by Hermès Paper, clear glass and velvet ribbon, 1961 M.I.P. Collection

RECIPES

JASMINE POWDER.

GRIND some soapstone, sift it, put it in a box and strew jasmine flowers over it. Close the box and renew the flowers every twenty-four hours. Then crush together a few grains of civet & amber and a little sugar candy. Mix with your powder.

ABDEKER or the Art of Preserving Beauty – Volume III L'An de l'Hegyre (The Hegiran Year), 1170

JASMINE WATER.

The perfume of the jasmine is generally pleasing. It is one of the sweetest and most pleasant scents of all the flowers. It triumphs over the Violet. This water is a difficult work, I would say, to preserve the odour and the taste of the flower itself. Here is the real reason in a few words.

This flower is not of the same composition as the Orange flower, the oily part of which retains the sweet-smelling parts as linked together. This is why the Orange flower keeps its scent for a long time: the bitterness of its salt preserves its taste. So true is this that most of the Household's servants whiten the Orange flower to extract, they say, its bitterness. They thereby claim to give the liquor greater refinement. I do not wish in any way to dispute an operation with which they are satisfied, but I for one would never use it, for the reason that in whitening this flower, the volatile spirits and salt escape and dissipate. It is precisely this volatile spirit and salt of this flower which is most precious and which abounds the most. So much so that in whitening the Orange flower, one puts oneself to a great deal of trouble to make an inferior product. And if the Artist were to take it upon himself to whiten the Jasmine, all the scent would dissipate and only the taste of grass would remain, because the sulphurous part is a volatile spirit which does not cling to this flower through any oily parts, and escapes easily through evaporation. The taste of salt in the Jasmine is negligible and not at all harsh, but verging on the sweet, and is dissolved just as easily as the perfume dissipates. Thus all the parts of this flower place Artists in such a predicament that they have not so far been able to use them as they would have wished. The only means they have found has been to use the Jasmine oil, which is an essence more suitable for feeding and perfuming the hair, than for making alcohol which may taste completely of Jasmine.

If I am asked why the oils have the complete taste or smell of this flower, and why it is so difficult to impregnate it on the alcohol? The most sensible reason is that this flower only has volatile salt and spirit. This may explain why the oil or essence of the flowers can only be made in two ways.

The first way, as we demonstrated in the Treatise on Distillation, of placing the flowers on suspended linen cloths impregnated with oil of sweet almond and hazel

◀ *"First" perfume bottle by Van Cleef & Arpels Clear glass, 1976 M.I.P. Collection*

111

nut, or oil of Ben, as soon as the flowers are on these linen cloths, the box is tightly closed so that there is no air in it, in order that the volatile spirits cannot be given off. By this method the spirit of the flowers, which is the perfume, infusing the box, settles on the oil-impregnated linen cloths which attract and preserve it, as we can see.

The other way in which oil is drawn from the flowers is for a dual purpose. They are mixed with ground almonds. A bed of flowers and a bed of almonds are made. A box suitable for this operation, which we shall discuss in greater detail following this Treatise, is then filled in this way. Having changed the flowers several times, when the Artist finds that his almonds have enough perfume, he separates the flowers from the almonds, he draws the oil off without heating it, and this oil is a very delicate, very sweet-smelling essence.

When the remainder of the almonds have been drawn from the press, they are crushed again, passed through a sieve and confined in tinplated boxes to preserve the scent, and this paste is what is called the "Pâte de Provence" (paste of Provence). It is used to wash one's hands and soften one's skin. It gives off a fine scent. Of all the flowers, Jasmine is the most esteemed.

These oils, however good they may be, never have the taste, when working them, of the Jasmine itself. It is therefore very important to use the flower itself and to draw off, carefully, vigilantly and laboriously, these volatile spirits which make up its perfume, so exquisite and so fashionable.

When an Artist, jealous of his reputation, wishes to make Jasmine Water, he must buy the flowers while still on the plant, pick them himself, and if he cannot do this work on his own, he must have assistance.

Immediately after sunrise, the flower must be picked, any greenery removed, and gradually placed into a Florentine flask as far as it will go. When it is full you put in cotton-proof spirit, as much as the flask of flowers will hold, so that the flowers do not lose anything and the alcohol soak up all the perfume. You place your infusion in a cool place and after six weeks you separate your alcohol from your flowers and leave them to rest until the cloudiness of the alcohol produced by the flowers has dispersed or subsided. You then draw it gently off in the flasks to use as you please.

Note that it is not the small Jasmine which you should use, but the large-flowered Jasmine called Spanish Jasmine because of its origin. Recently picked flowers are of a substance which lasts long enough to leave a vacuum containing the alcohol.

This is the best way of making this Water in all its excellence. It is costly, but its value must be appreciated.

Those who use Jasmine oil must firstly ensure, in order that their alcohol has the scent of this flower, that the oil they use is that year's oil, and secondly, that the said oil is made with Ben. Thirdly, that it comes from Rome or Spain, which is the best of all due to this flower's superiority in this climate, when it is made by a skilful Artist. It is more fragrant and sweeter smelling. These are the reasons why it is given preference.

To make this Jasmine Water, take a quart of Jasmine oil which has the qualities described above. Place it in a pint of rectified alcohol and as many quarts of oil as pints of alcohol you put in. Plug it well, and the oil will subside. Turn it upside down every day for a fortnight so that your spirit blends with the oil. After the said fortnight, let it rest for a further week without touching it, and the spirit will be in a state for extraction and bottling for selling.

M. DEJEAN: Treatise on Scents, following the Treatise on Distillation, 1764

JASMINE.

There are two species, both good ones to use: the common jasmine and the Spanish jasmine, which has much lovelier, larger, fuller and sweeter smelling flowers than those of the common jasmine, white inside, reddish outside. It is the latter which Distillers use as a rule. Perfumers make very extensive use of it.

Jasmine must be picked before sunrise so that it loses nothing of its perfume, and so that it has this virtue which the night air and coolness imprint on all the flowers.

The flower must be torn from the green cup in which it is enclosed and used immediately, lest it lose something of its perfume. When you have picked it, place your flowers in the still with water and the alcohol given the recipe.

This done, light a slow-burning fire and place your still over this fire. Distil your flowers. Pay particularly close attention in distilling to ensure that no phlegma occurs, as you will spoil your liquor which would no longer have its perfume. In distilling jasmine, the perfume rises first. When you have drawn off all your alcohol, quickly plug your container. Then melt some sugar in fresh water. When your sugar has melted, instead of pouring your alcohol into the syrup, pour the syrup into the container over the perfumed alcohol.

Plug the container immediately, and do not heat it until the following day to give the distilled alcohol time to cool completely to preserve its scent which, if exhaled, would damage your liquor, and finally, so that this same alcohol penetrates the syrup fully.

Take care when you heat it to cover the funnel well for the same reason. It is only by properly heeding what we say that you will be able to make good jasmine water. This is no small talent for the Distiller.

There is so little that is good that whoever does it well has a very good part in this art.

Moreover, as the conduct of this distillation is one of a Distiller's scientific points, he who is capable of making jasmine water well, is in a position with some knowledge to conduct his other operations well.

I believe that the quintessence can be drawn from the jasmine and other flowers from which essences are made. Although the scent of the jasmine is extremely sweet and no-one, I believe, has attempted this experiment, I think that it can be drawn off, as with roses, by adhering to the same method as we have given for making the quintessence of this flower, in the twenty-fourth chapter where I deal with this in detail.

Recipe for six pints.

Use three pints and a half pints of alcohol, one pint of water, six ounces of jasmine, and one pound of sugar and three and a half pints of water to make your syrup.

To make your jasmine water fine and mellow, use four pints of alcohol, one pint of water, and four pounds of sugar and, for the syrup, two and a half pints and a demi-poisson of water and eight ounces of jasmine.*

To make your liquor fine and dry, use four pints of alcohol, one pint of water and, for the syrup, two pints of water, two pounds of sugar and ten ounces of jasmine.

Eight ounces of jasmine may be infused in the three and a half pints of alcohol for one month. After this time, make your syrup by putting in at least half a pint of

* Translator's Note: ''demi-poisson'' = a half-unit measurement of some kind, unknown today.

alcohol because the jasmine will have weakened the alcohol. Your liquor will then be perfect. This operation is the best one.

M. DEJEAN : Reasoned Treatise on the Theories of Distillation or Reduced Distillation – Chapter XXVII, 1778

JASMINE POMMADE.

Take ten pounds of purified substance prepared according to the method already indicated, melt it over a water-bath, then add four ounces of levant storax and four ounces of benzoin. Let it all infuse as you did

previously, then melt it again until it clarifies and put it back over the water-bath, adding a pound and a half of good fat perfumed with the orange flower and half a pound perfumed with cassia. Allow your prepared substance to cool, and then spread it over your frames to deposit the flowers on it, as above. Melt it again and clarify likewise, and when it is half-cooled, add a few drops of essence of amber and musk. I observe that this pommade fetches a very high price in Paris, given that jasmine is scarce compared with the wide use made of it.

Jasmine oil.

I shall begin with this, which will serve as an example for the others. This flower, being one of the most valuable for making perfume due to its sweet scent, is also one of the most delicate, and demands the most careful work. This is the way in which the oil is drawn from it.

Pick the Jasmine before sunrise so that it has all its perfume, and the virtue which the cool night air imprints upon all the flowers. Pull the flower out from the cup to which it is attached, and use it immediately so that it loses none of its perfume. Then spread it over your linen cloths in the manner prescribed and to a depth of two fingers and more if you are able. Continue changing your flowers ten to twelve times every day until your oil is very fragrant. Press your linen cloths and clarify as stated above. You will have one of the most agreeable oils in the sweetness of its perfume. Since this flower does not produce essential oil, every care should be taken to make it well. The scent may only be extracted by means of the fatty substances and by introducing it into the alcohol to extract the odour. It is therefore vital to use the best oil so that the alcohol in which these oils are placed assumes only the perfume of the jasmine without retaining an oily odour, which is what would happen when using oil of an inferior quality.

Jasmine. Of these charming shrubs, some succeed in the open soil and form fragrant bowers, others only survive in glass houses. But their natural climates are the southern countries. They grow easily and produce flowers in abundance. Here, they do not flower until the end of the summer. They need this season for their sap to heat up. I make an exception for the small jasmine which comes on earlier and does not produce enough for the work.

The scent of the jasmine is very volatile. The oil cannot be extracted from it by distillation. This guiding spirit is obtained by means of the fatty substances, and by another process you impart this scent by placing your fatty substances in wine alcohol, as is explained above in the recipes.

C.F. BERTRAND : The Imperial Perfumer, 1809

POMMADE OF JASMINE.

Perfume 5 kilograms of well purified substance with 125 grams of benzoin. Melt and separate it, let it cool, then spread your pommade for saturation. Some perfumers prefer to leave only the scent of the jasmine and remove the benzoin. They are right, but then the pommade is dearer, because it must saturate for

114

longer and use more jasmine, of which it is difficult to obtain sufficient supplies. Finish as stated above.

POMMADE OF JASMINE.
Perfumed fat prepared with benzoin 750 grams
Fat perfumed with jasmine 250
This pommade can be prepared as follows:
Purified white fat 1000 grams
Powdered benzoin 30
Powdered calamite storax 30
Melt over a water-bath and leave for one day to infuse.
The following day, melt it again, sift it, put it back over the water-bath and perfume with:
Fat perfumed with the orange flower 200 grams
– with cassia 100
– with jasmine 300
A few drops of amber and musk tincture.

JASMINE AND JASMINE-JONQUIL ALUM POWDER.
500 grams of alum, 187 grams of iris, 60 grams of jasmine powder. To make the jasmine-jonquil alum powder, add 60 grams of cassia powder.

LIQUID JASMINE PASTE.
Proceed exactly as for the Flora paste, substituting the spirit of jasmine for the spirit of rose, and 60 gr. of jasmine huile antique for the drops of rhodium and essence of rose. Add a little essence of amber.

ESSENCE OF JASMINE.
Place a sufficient quantity of jasmine flowers into a stone jug, and pour in sufficient Ben oil until they are completely covered. Leave to macerate for a fortnight by exposing this well covered vase continually to the sun. Squeeze then express slightly. Put the oil back into the jug with the same quantity of flowers and squeeze again a fortnight later.

Finally, by repeating this operation a third time, an oil is obtained which is filtered, and which is heavily impregnated with the scent of the jasmine. This flower cannot be distilled.

The same results would be obtained if, instead of the Ben oil, pure, non-rancid lard were used.

SPIRIT OF JASMINE.
This spirit is again obtained by the same processes and is used in the preparation of many fragrant waters.
Spirit of Jasmine.
Alcohol 85°C 25 litres.
Extract of jasmine, between 500 and 1000 grams.
Extract of Jasmine.
Alcohol at 85°C 2 litres.
Extract of jasmine 1 litre.
Tincture of tolu balsam 15 grams
– of benzoin 15

– of amber 5
Extract of superior-quality jasmine.
Extract of jasmine (1st batch) 13 litres
Infusion of amber 1
– of musk (1st batch) 1/4
Re-distilled Montpellier spirit 4
Mint or jasmine paste.
Take:
Mint or jasmine flowers 30 grams
Gum tragacanth 15
Cinnabar 60
By this means you will have red pellets and it will be easy to vary the dyes by using, in varying degrees, different colouring substances. Use cautiously when cinnabar is used.

EXTRACT OF JASMINE VINEGAR.
Take:
Natural vinegar 60 litres
Orange flowers with husks 2 kg
Distil and withdraw 30 litres, to which you will add the perfumed fat extract or spirit of jasmine, at a rate of 30 grams per litre.

P. PRADAL and F. MALEPEYRE: Manuels-Roret – Practical Simplified Treatise on Perfumery, 1873

▶ *Jasmine essence bottle*
with glass stopper
Brown glass, c.1950
M.I.P. Archives

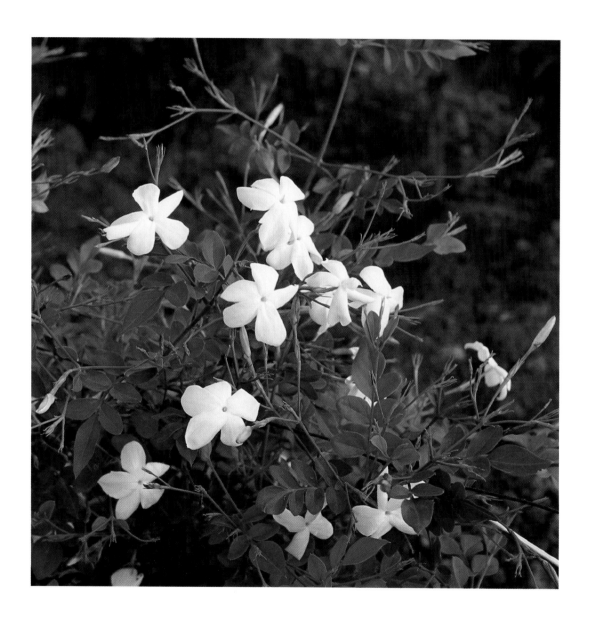

QUOTATIONS

Dorante
I had taken five boats the better to settle all
Four containing four choirs of singers

...

The fifth was large, purposely decorated
With intertwined branches to keep it cool,
Each end of which carried a sweet mingling
Of bunches of jasmine, pomegranate and orange flower
Pierre CORNEILLE : le Menteur (The Liar)- Act I, Scene V, 1643

Jasmine (Jasminum vulgare) originates from the Indies and is familiar to every-one.
Spanish Jasmine (Jasminum catalonicum) thus named because it was first of all brought to Spain from its natural habitat in Malabar. It has been grown in Europe for more than two hundred years.
The sweet-smelling yellow Jasmine (Jasminum indicum, flavum, odoratissimum) is due to the famous Peyresic who, according to his Historian, received it from China. This Scholar, whose talents extended to all subjects, grew the rarest plants in his garden at Beaugencier. He informed Gui de la Brosse of it, Plant Demonstrator in the King's garden, in Paris, and since that time, jasmine has continued to be grown, except in Provence, where it no longer exists.
Arabian Jasmine (Nydanthes) has been transported from Egypt for almost two hundred years. As it was widely known in the neighbouring countries, and particularly in Arabia, it kept the name of Spanish Jasmine, although its natural habitat is the East Indies.
Abbé PAPON : Voyage de Provence, 1787 (Travels in Provence)

She had never seen white camellias, she had never smelt the Alpine laburnum, the citronella, the jasmine of the Azores... all these divine scents arousing tenderness and singing with the soul the hymns of perfumes.
Honoré de BALZAC : Le curé du village, 1839 (The Village Priest)

He replies : – You have been heard.
Fearing nothing of time, the enduring immortal
Is the true symbol of a faithful friendship.
The narcissus discerns an insane desire
And the jasmine lover demands pleasure ;
A. DEBAY : Perfumes and flowers, their history and various influences on the human economy, 1846

Oh fields! Oh fields of Grasse, oh fertile hills,
Oh cultivated crags, oh silvery sources.
Oh myrtles, oh jasmines, oh forests of orange flowers...
Abbé COGNET: A. GODEAU, Bishop of Grasse and Vence (1605-1672), 1900

In the town of Grasse itself, between the villas, are little fields of jasmine. Not the climbing plant, the fragrant creeper with the dark leaves and small flowers of northern climes, but a shrub only 70 to 75 centimetres high, the branches of which are draped over the reeds. This jasmine is grafted on to wild stock gathered in the forests where it abounds, or imported from the Eastern Riviera. The upper part of the plant only thrives for one summer. It is cut back in the autumn, leaving only the stump, and the root stock is covered with earth. The blossom is superb, the large flower like a two-franc piece, gives off an exquisite, but violent perfume. One woman can gather 1 to 2 kg of it a day. Each foot can provide 2 kg at most during the season, and 100 kg are needed to provide only 12 grams of essential oil.

At this moment, the harvest is in full swing. The flowers must be picked before eleven o'clock in the morning or between five and seven o'clock in the evening. Women and girls work feverishly, their heads covered with a wide-brimmed hat. Most are from Piedmont. They arrive each year in December in their thousands for the olive harvest, bringing all their children old enough to work with them. Living twelve to fifteen to a room with the utmost frugality, they are thus able to take back the greater part of their wages of 1 fr. to 1 fr. 50 centimes per day to their mountains of the Eastern Riviera or Coni.
Ardouin DUMAZET: Voyage en France, 1904 (Travels in France)

... The memory of the dual perfume clinging to the curtains: English tobacco and jasmine a little too sweet...
COLETTE: La Vagabonde, 1911 (The Vagabond)

I inhabit the crags, but what happy destinies
Have carpeted everywhere with roses, jasmines,
From the foot to the summit, the trees cover them,
The rich orange flowers blossom on the plains.
Georges DOUBLET: Antoine GODEAU, Bishop of Grasse and Vence (1605-1672), 1913

The evening came... The jasmines which, through their day-long efforts, had succeeded around dusk in fastening on to my window, had to surrender when I opened it and inundated me with perfume, pollen and stamens.
Jean GIRADOUX: Siegfried et le Limousin, 1922

The earth in Grasse, says Masse, is weary of jasmine.
Théoule added the influence of old growths to this general idea. When I was small, there was a fig tree here, a peach tree there. The father planted jasmine. Eight years later, the plants were dead around the peach tree and two years later muffle attacked those around the fig tree. The old roots sent root rot down into the earth. I said to my sons, "Never plant jasmine where other trees have been. You must know the land's heredity."
Women squatting in the jasmine worked, almost sitting on the ground. The click of the secateurs biting into the little branches was the only noise in these gardens of patience where the worker's hand lightly touched on all the plants stem by stem.

On the espaliers aligned on taut wires, straw ties fluttered like insects. In the oldest crops the flaxen reeds controlling the jasmine traced clear lines over the gravity of the gentle, thornless plant.

They heard their growing sighs... The proud man dominating, and the woman furious at losing herself in him, murmured the groan of their immense tenderness...

The woman's thrills of pleasure stirred in the depths of her body without rippling the skin tightened by the firmness of her flesh...

This lover's perfume evoked the work of the Guigue factory where Denise, impassioned by the sweet scents, had taken essential oils. In the breath of the wind over these fields of sweet-smelling plants, love gave off a rare scent, no flower of which held the mysterious power.

Paul asked:

– Which scent dominates the wind this evening?

– Jasmine, she said.

He replied:

– You. The garden of your body is sweeter than all the gardens together.

The multitude of worlds ruling over the multitude of flowers. The greenery studded with white jasmine. The earth balmy with their delicious nocturnal sigh. The dominant scent was as profound and fine as the light. Two kinds of sweetness emerged: the light and the perfume. The rose would give up its soul to the sun, the jasmine to the stars.

When the flowers were in full bloom, we had to watch the sky at night and call as soon as we saw any clouds so that the flower could be plucked before the heavy rains of the storm struck it down. We picked by the light of lanterns hanging on the espaliers. The children, frightened by the approaching lightning, were harshly controlled so that they could get ahead of the gusting wind.

Night work was a regular custom at a time when the perfumer would say:

– The jasmine's scent is greater in the evening. Do not pick it when the sun is shining.

The peasant, raising his cap, would reply:

"As you wish, Master!" and would stay watching over the espaliers as long as the white flower was visible, and then would begin again at dawn.

The white pile of jasmines in the fats hall draped her in sashes of perfume, the sweetness of which made one's eyelids slowly blink. Impassioned by sweet-smelling flowers, she would put them by the handful against the faces of the girls who would gladly take them and smooth them over the greased panes of glass.

The jasmine flower, said Mr Massiera, thrives intensely after picking. It makes seven to eight times its own perfume. This is why it is placed cold on lard which it slowly impregnates. You can see how many women are needed to do this. It is an expensive process today. We therefore put a lot of jasmine directly into petroleum ether which extinguishes the perfume in one go, instead of benefiting from its survival. But this operation means that four thousand kilos of flowers can be processed in one day with four men.

As the sun set behind the hills, the area became heavy with the sweetest scent. Jasmine, the terrestrial star, did not open until dusk. The eruption of the white August perfume, more powerful than the Rose de Mai perfume, covered the trees of the Estérel. The charm of the luminous shade would grow as the flower breathed.

Pierre HAMP: "La peine des Hommes", Le Cantique des Cantiques, 1922 (The People's Sorrow, Song of Songs)

The warm perfumes, clear, luminous, unadulterated perfumes with a decisive fragrance, singing in a steady key and with a lively rhythm, in harmony with the ochres, the carmine, cobalt and orange flower.

Examples: geranium, jasmine, lilies, lilacs, white and red roses.

André MONERY : L'âme des parfums – Essai de psychologie olfactive (The soul of perfumes – Olfactory psychology tests), 1924

The end of July was jasmine time, and August that of the nocturnal hyacinth. Both these plants had such exquisite and yet such fragile perfumes that not only did their flowers have to be picked before sunrise, but they also required the most delicate, specialist exhausting process. Heat subdued the perfume, and sudden immersion in boiling fat and maceration would have destroyed it. These noblest of flowers would simply not allow their soul to be plucked out, it would literally have to be taken from them by guile and flattery. On premises set apart for their 'enfleurage' (saturation), they were spread over glass plates smeared with cold fat, or else they were softly enveloped in oil-impregnated linen cloths, and there they would die by gently falling asleep. It took three or four days for them to fade and give off their perfume to the neighbouring fat or oil. They were then cautiously removed and fresh flowers spread. The operation was repeated ten or twenty times until the pommade was saturated and the fragrant oil could be expressed from the linen cloths. This was in September. The result was still clearly thinner than in the case of maceration. But the jasmine paste or 'huile antique' of tuberose obtained by this cold saturation were of a quality which outclassed any other products of the perfumer's art, so fine and faithful were they to the original. In fact, one had the feeling with jasmine that the erotic scent of the flowers, sweet and persistent, had left its image on the greasy plates as a reflection in a mirror, which now reflected it quite naturally "cumgrano salis", of course. For it goes without saying that Grenouille's nose still detected the difference between the scent of the flowers and their preserved perfume.

Patrick SÜSKIND : Le Parfum, 1985

It was a composition of both serene and happy harmonies....

And how "their little one" was able so prettily to imitate the loveliest in nature delighted them all...

And one sensed her pride, not in playing her music, but in saying: "Mummy's field of jasmine, it, too, knows that it is the sweetest smelling, it says: "I am Mistress Sorenza's jasmine garden, where the perfume rises once evening comes, higher than the great chimneys of the factories, ever higher, right up in to the sky...".

Janine MONTUPET : Dans un grand vent de fleurs, 1991 (In a great gust of flowers)

... And from Bordeaux to Marseilles, Agen has poured out such a wave of poetry that we are quite luminous. Singing of love better than a woman, and stirring the heart with the sweetest upheavals, we have seen Jasmine wring tears from us... But we loved her, you know why? As Pindar loved his Thebes, he spoke to us with pride of Agen, of Villeneuve, of Auch, and of the hamlet of Estanquet.

Frédéric MISTRAL : Les Iles d'Or, Les Sirventes. (The Golden Isles, The Sirventes)

APPENDIX

A FEW JASMINE-PICKING SCENES IN EGYPT

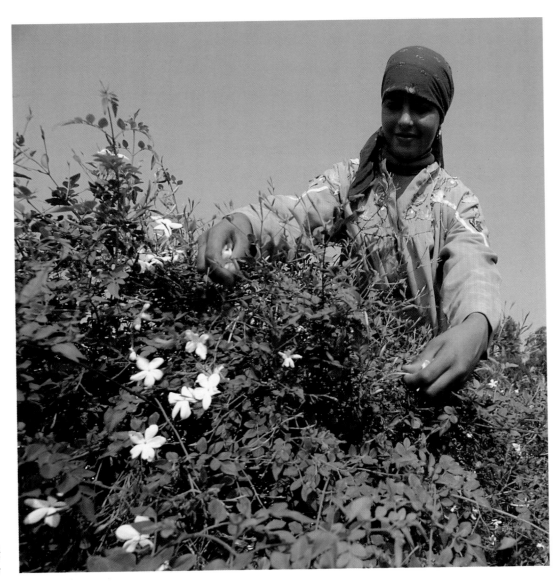

Jasmine-picker,
Egypt Summer, 1995
M.I.P. Archives

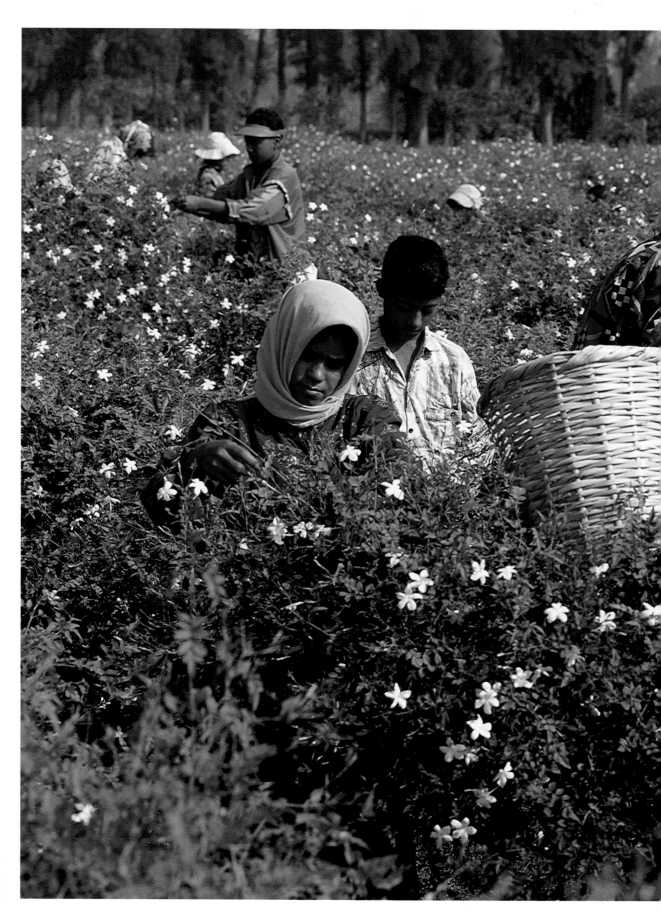

Jasmine-picking,
Egypt Summer,
1995
M.I.P. Archives

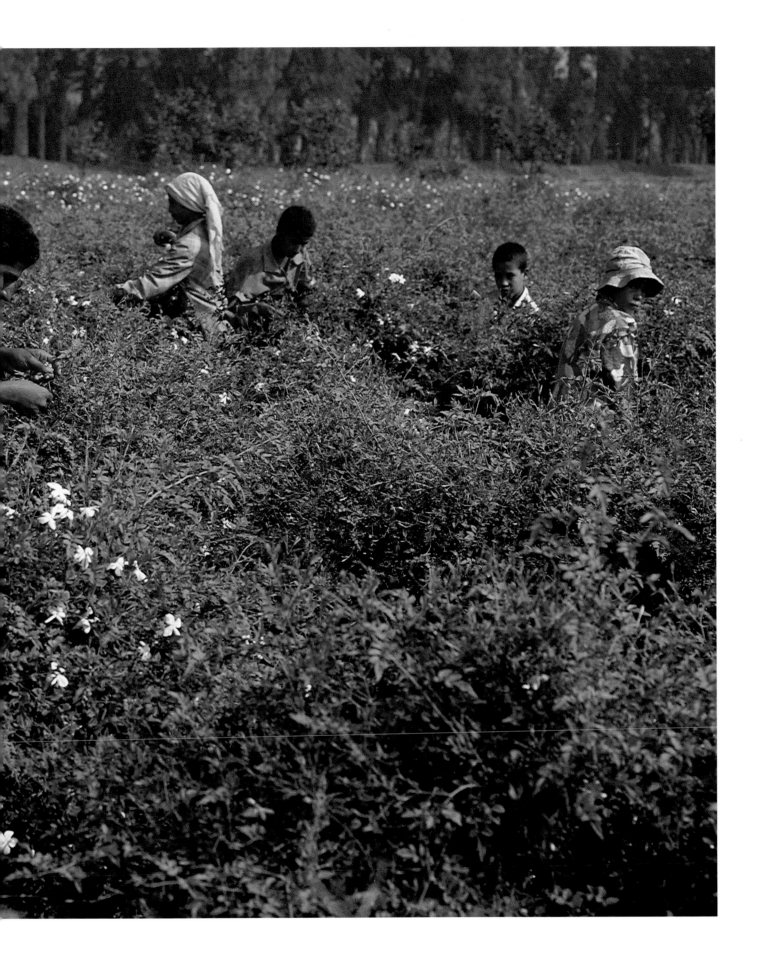

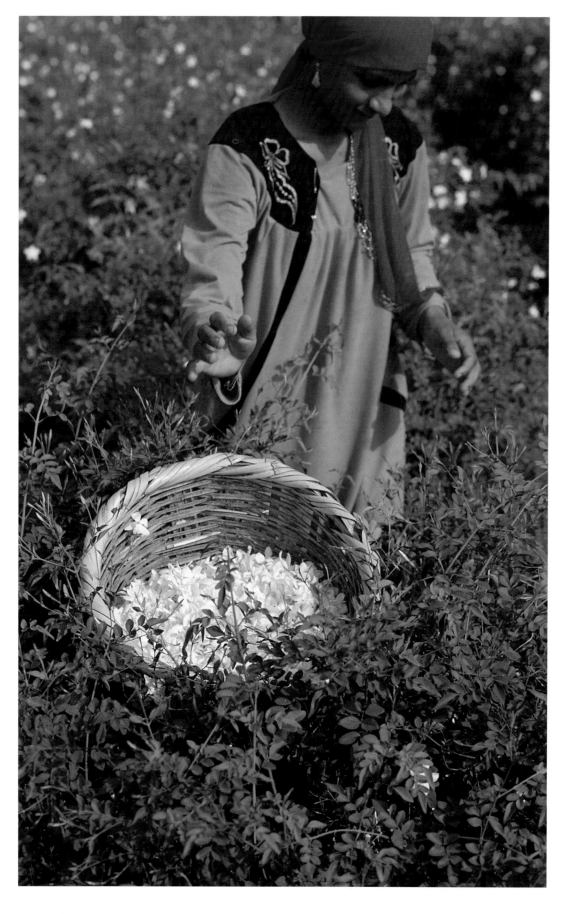

Jasmine-picker, Egypt
Summer, 1995
M.I.P. Archives

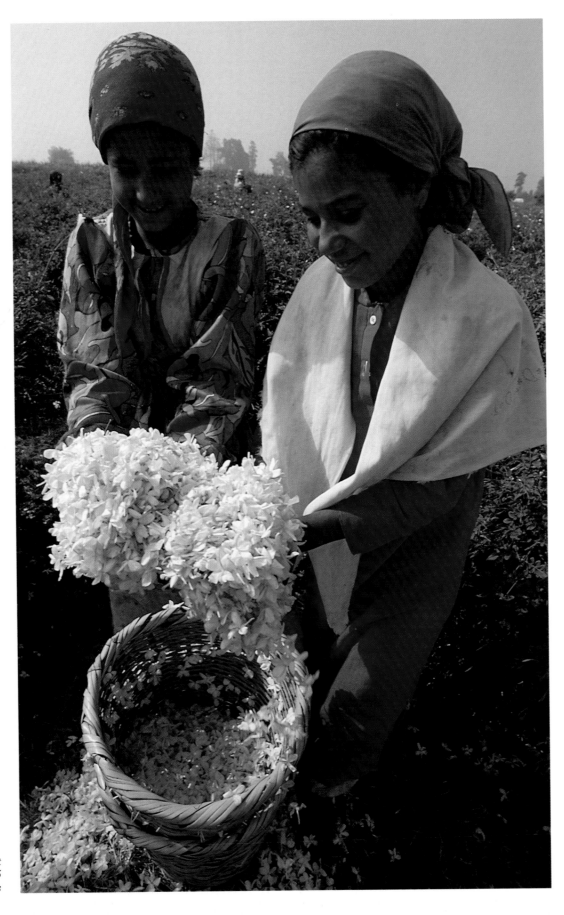

Jasmine-pickers, Egypt
Summer, 1995
M.I.P. Archives

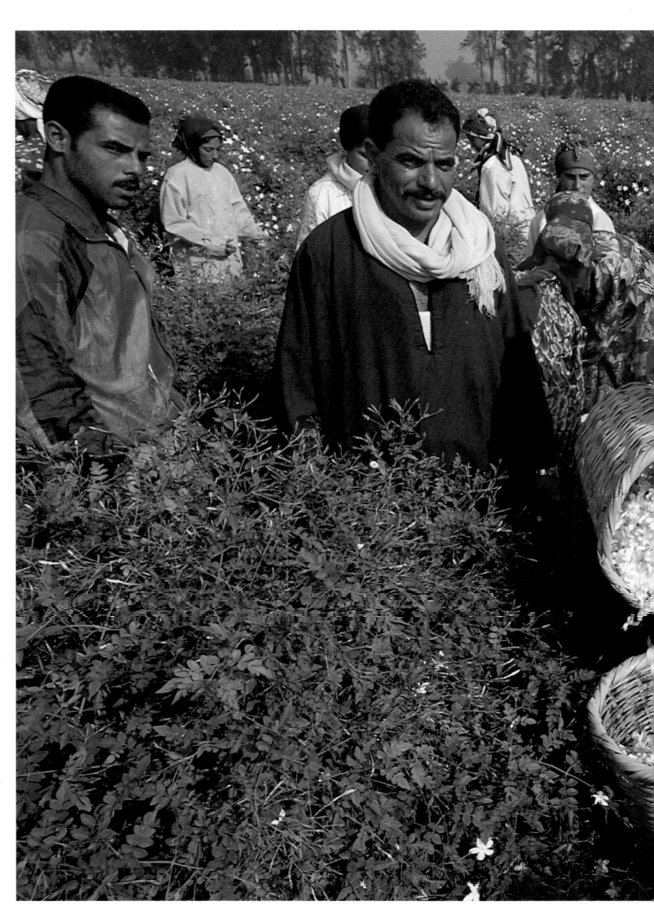

In the jasmine fields,
Egypt Summer, 1995
M.I.P. Archives

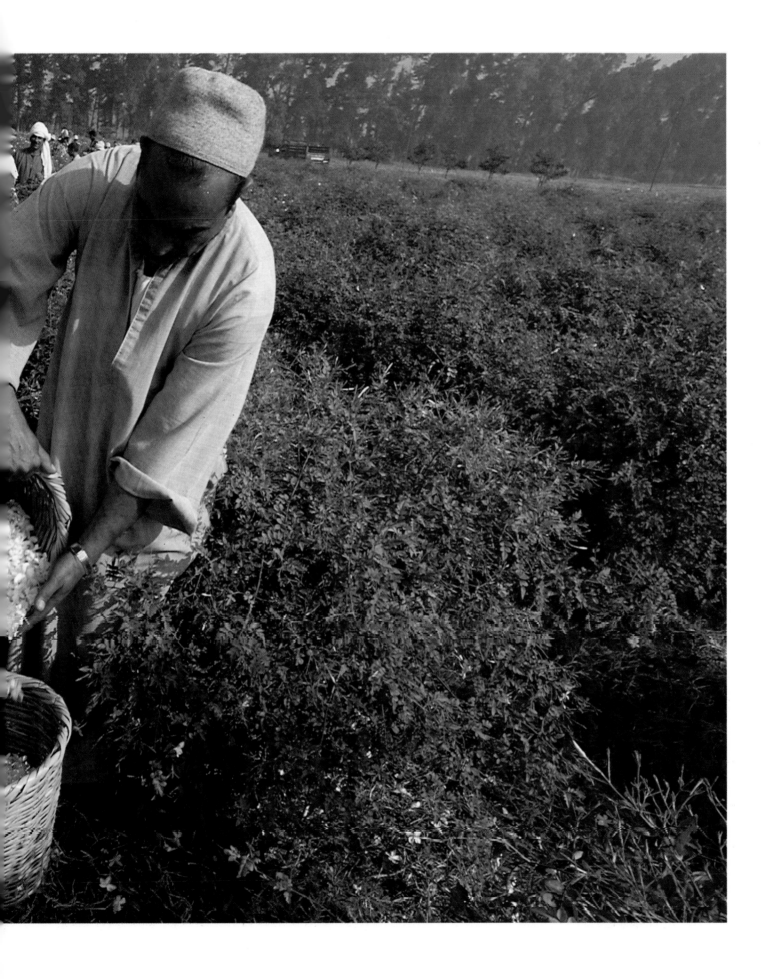

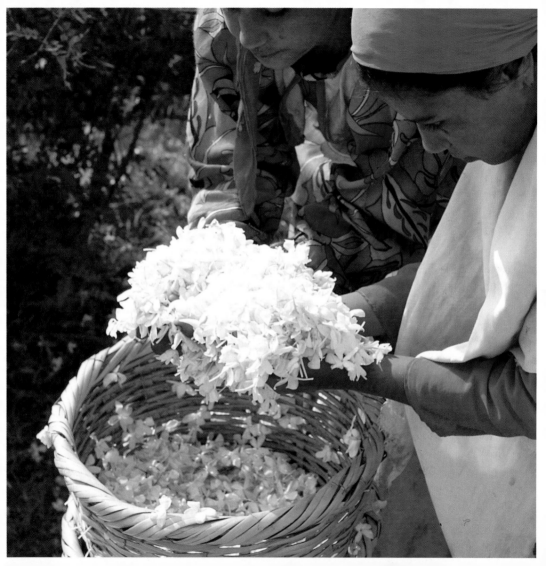

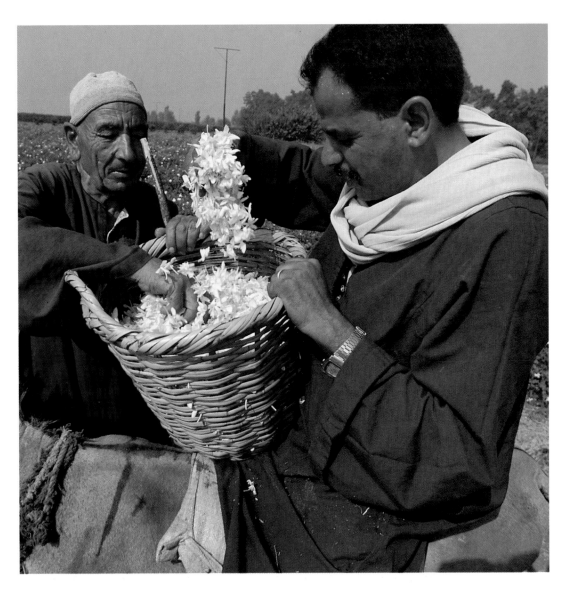

*Above: Examination
prior to weighing
Egypt, Summer, 1995
M.I.P. Archives*

◄ *Facing page:
A large handful of
jasmine flowers
Egypt, summer, 1995
M.I.P. Archives*

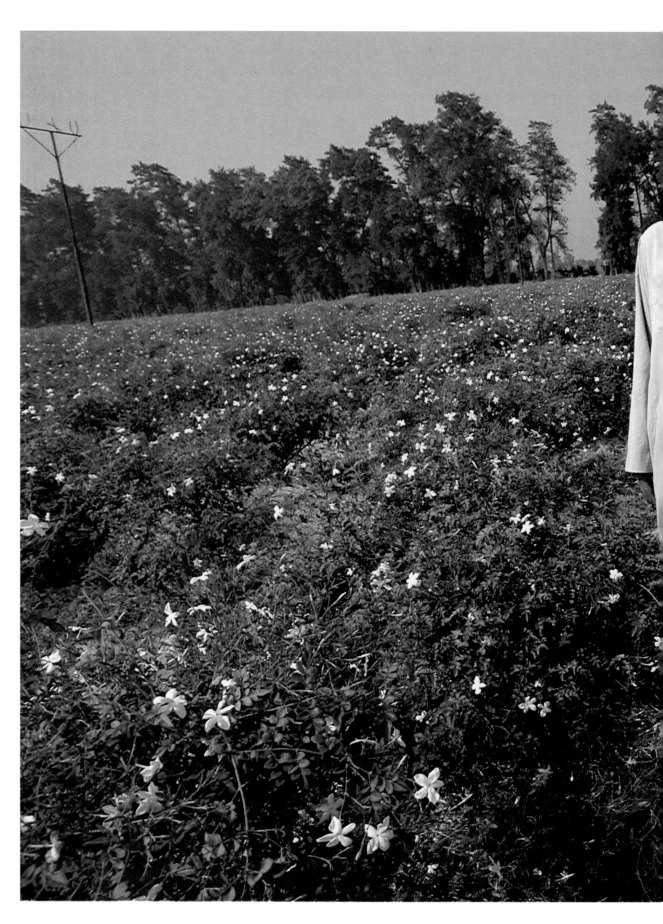

Picking supervisors
Egypt, summer, 1995
M.I.P. Archives

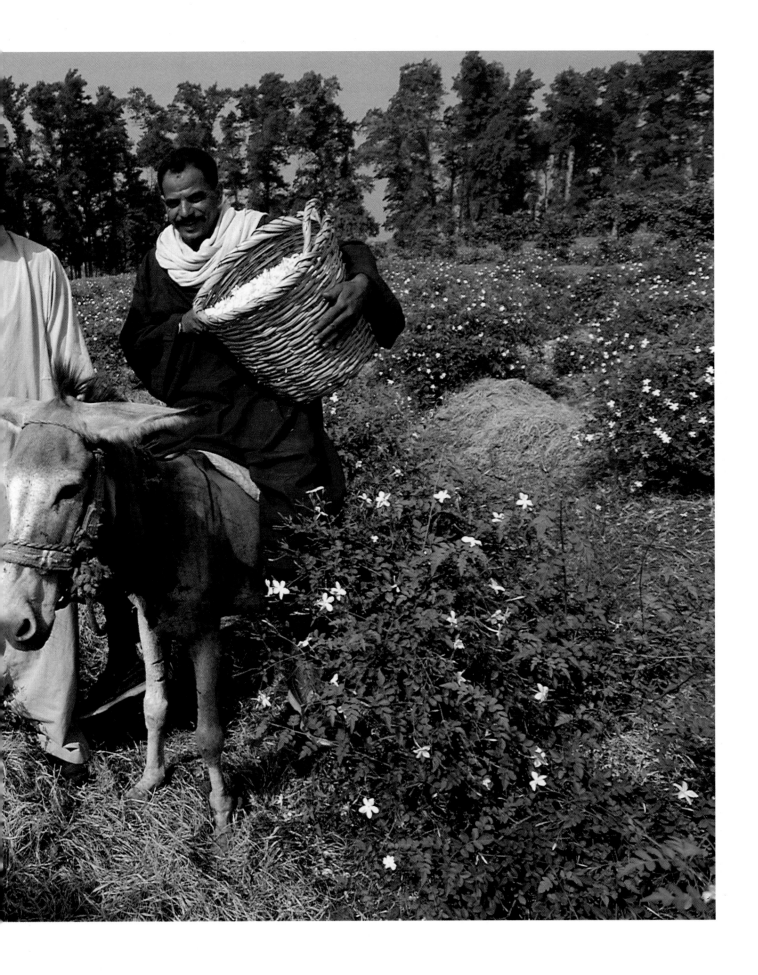

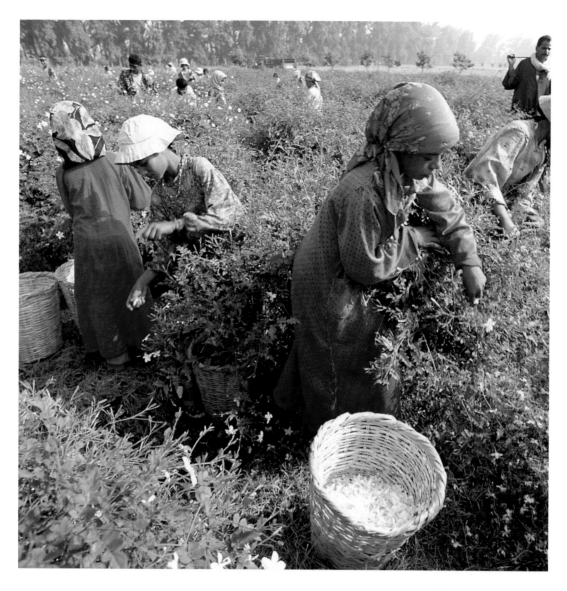

Above: Jasmine-pickers
Egypt, summer, 1995
M.I.P. Archives

Right: Jasmine-pickers
pouring their harvest
into a basket
Egypt, summer, 1995
M.I.P. Archives

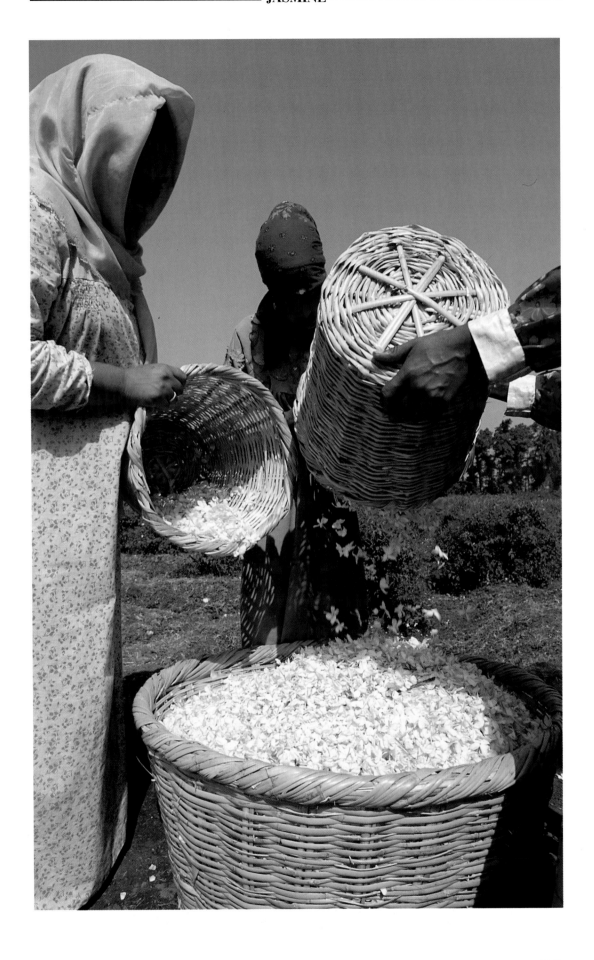

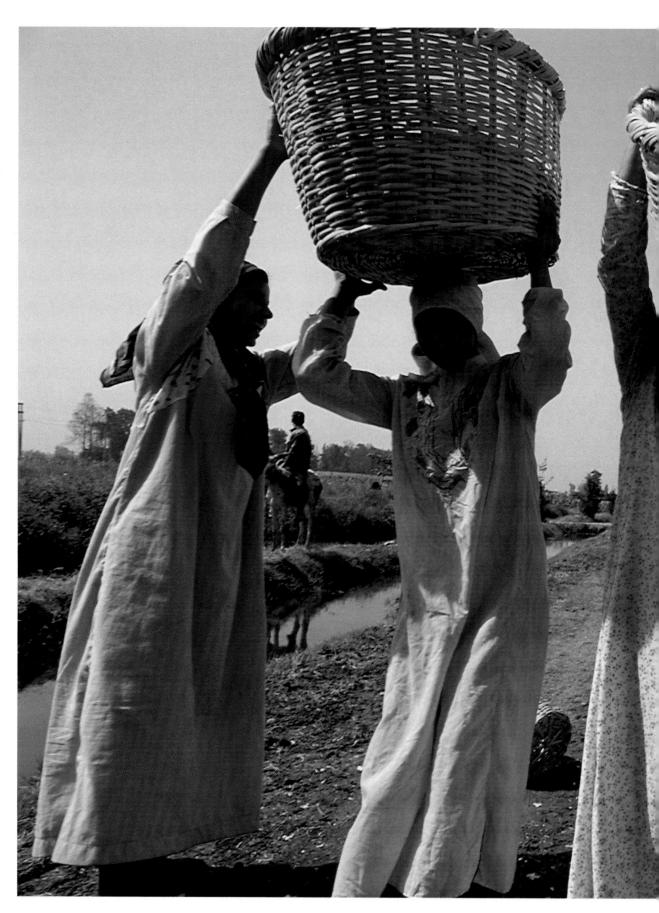

*Baskets are carried
to the weigh-in
on the pickers' heads
Egypt, summer, 1995
M.I.P. Archives*

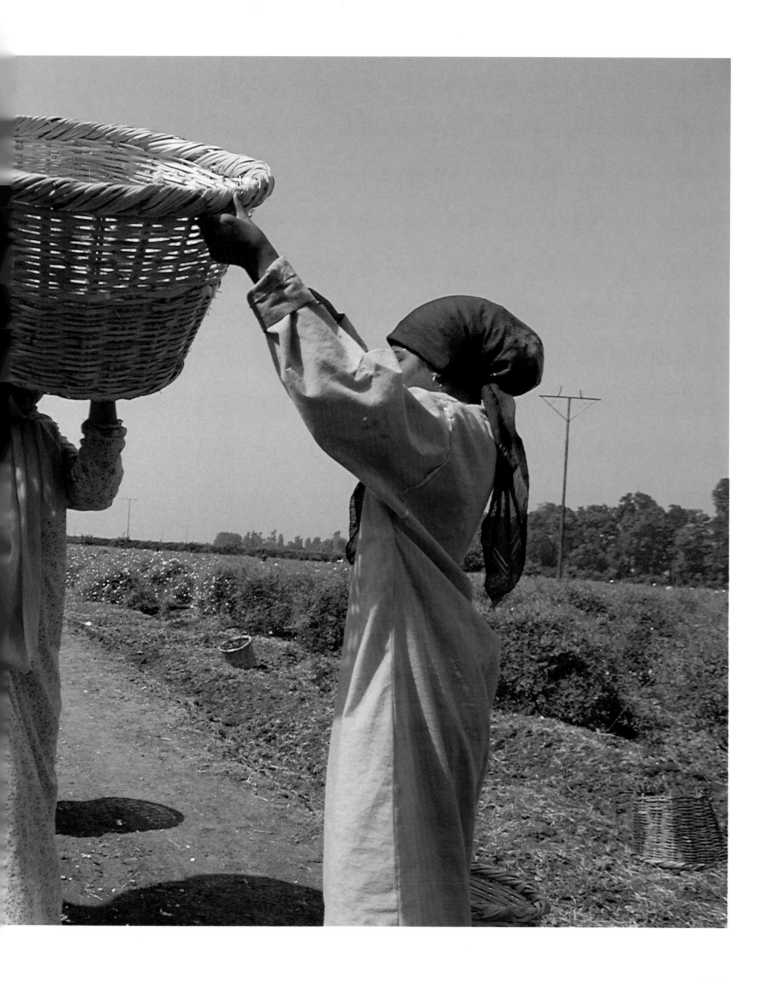

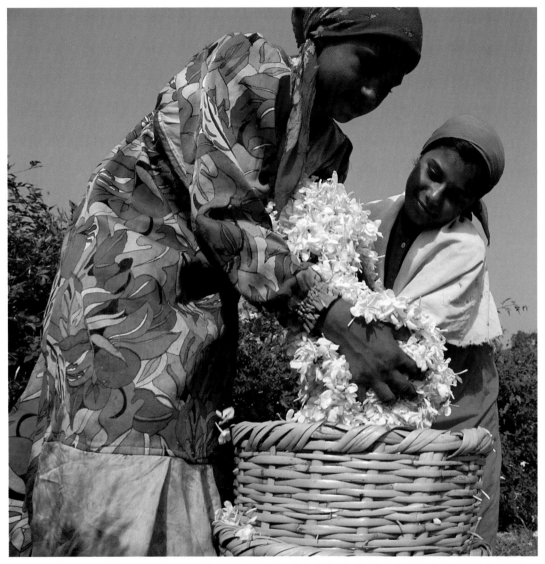

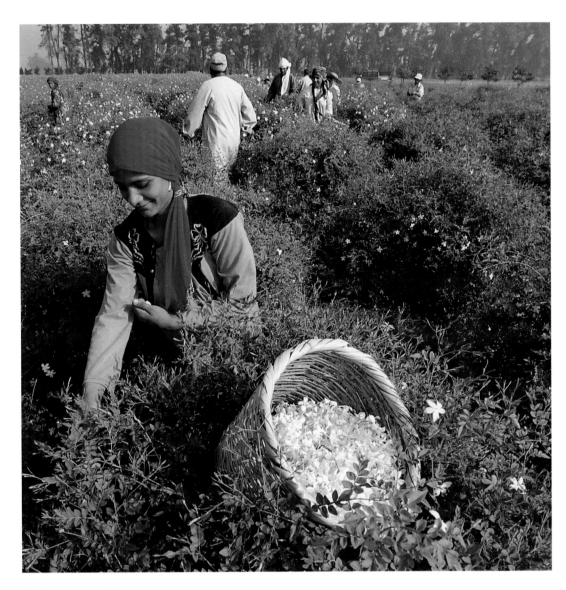

◄ ▲ *Above and facing page:*
Jasmine-pickers
Egypt, summer, 1995
M.I.P. Archives

ACKNOWLEDGEMENTS

The exhibition, "Jasmine, Flower of Grasse", was organized by the town of Grasse, assisted by the Ministry for the Arts,
And supported by the following companies:
- Givaudan-Roure,
- Haarmann & Reimer,
- Kato International,
- Sotraflor.

This exhibition would not have seen the light of day without all those who generously made previously unpublished documentation available to us. We would like to take this opportunity to thank them.
Many institutions have been willing to lend us items and have thus made this exhibition possible. We would like them to accept our sincere thanks.

With the aid of the: - Musée Granet, Aix-en-Provence,
- Musée de Picardie, Amiens,
- Musée des Beaux-Arts, Caen,
- Musée des Beaux-Arts, Carcassonne,
- Musée Hospitalier, Charlieu,
- Musée de Tessé, Le Mans,
- Musée des Beaux-Arts, Palais Longchamp, Marseille,
- Musée des Beaux-Arts, Nantes,
- Musée d'Art et d'Histoire, Narbonne,
- Musée du Louvre, Paris,
- Musée des Beaux-Arts, Quimper,
- Musée National de la Céramique, Sèvres,
- Bibliothèque Méjanes, Aix-en-Provence,

and of: Monique et José Curau, Armand Deroyan, M. de Fontmichel, Jean Gismondi, Jean Lefebvre, Jean-Marie Martin-Hattemberg, Michèle et Alain Monniot, Michel Pastor, Francis Tarallo.

We would also like to thank the various municipal departments who have largely helped to prepare this exhibition.
We would like to express our warm thanks to all the members of the technical and administrative team of the Musées de la Ville de Grasse (Grasse Municipal Museums), who ensured that this exhibition was carried through:
- Ariane Lasson, Conservation Assistant.
Valérie Bia, Claudine Chiocci, Joëlle Déjardin, for the accuracy of the documentation.
Brigitte Chaminade, Nathalie Derra, Sandrine Papa, Danielle Soriano, for prompt secretarial assistance.
Micheline Vincent-Roubert and Agathe Miserez, for the photographs.
Noëlle Chatelain, Laurence Gallarotti, Alain Dufour, Gilles Flécheux, Alain Gre-

laud, Louis Grelaud, Eric Lesne and Serge Mucci, for visitors' reception, surveillance, handling and assistance with the museum displays.

Claudine Gallarotti and Dominique Maisondieu, for their invaluable assistance.

The Museum Services have mounted this exhibition under the kind auspices of Dominique Bourret, Deputy Mayor responsible for Cultural Affairs and the Fine Arts. Yves Ansanay, Assistant Secretary General responsible for Cultural Affairs, should not be forgotten, because his unfailing support has been invaluable to us.

Finally, we also wish to express our deep gratitude to Jean-Pierre Leleux, Mayor of Grasse, Vice President of the General Council of the Alpes-Maritimes, for his support for this exhibition.

Marie-Christine GRASSE
Conservateur des Musées de Grasse

PHOTO CREDITS

All the photographs are from the organizations credited, with the exception of the following:
Bibliothèque Méjanes, Aix-en-Provence: p. 23
Cresp, Michel: p.10; p. 86; p. 89; pp.123-139.
Galérie Jean Gismondi, Paris: p. 24
Martin André, Chanel: p. 71
Musée d'Art et d'Histoire de Provence, Grasse: p. 21; p. 28; p. 31; p. 39; p.40; p. 43; p. 45; p. 47; p. 48; p. 66
Musée International de la Parfumerie, Grasse: p. 6; p. 8; p. 13; p. 27; p. 30; pp. 32-35; p. 37; p. 38; p. 41; p. 49; p. 53; p. 54; pp. 57-60; p. 62; p. 67; p. 68; p. 73; p. 74; p. 77; pp. 79-83; pp. 100-107; p. 109; p. 110; p. 117; p. 118.
Naudou, Elisabeth and Jean: p. 64; p. 92; p. 95; p. 96; p. 98; p. 99.
Roudnitska, Edmond: p. 69..

CONTENTS